The Art of
Resonance

Other titles in the Theatre Makers series:

Adrian Lester and Lolita Chakrabarti: A Working Diary
by Adrian Lester and Lolita Chakrabarti

The Uncapturable by Rubén Szuchmacher, translated
by William Gregory

Julie Hesmondhalgh: A Working Diary
by Julie Hesmondhalgh

Julius Caesar and Me: Exploring Shakespeare's African Play
by Paterson Joseph

Simon Stephens: A Working Diary by Simon Stephens

Devising Theatre with Stan's Cafe
by Mark Crossley and James Yarker

Meyerhold on Theatre by Edward Braum

Edward Bond: The Playwright Speaks
by David Tuaillon with Edward Bond

Joan's Book: The Autobiography of Joan Littlewood
by Joan Littlewood, introduced by Philip Hedley

Steppenwolf Theatre Company of Chicago by John Mayer

The Art of Resonance

Anne Bogart

methuen | drama

LONDON · NEW YORK · OXFORD · NEW DELHI · SYDNEY

METHUEN DRAMA
Bloomsbury Publishing Plc
50 Bedford Square, London, WC1B 3DP, UK
1385 Broadway, New York, NY 10018, USA
29 Earlsfort Terrace, Dublin 2, Ireland

BLOOMSBURY, METHUEN DRAMA and the Methuen Drama logo are trademarks
of Bloomsbury Publishing Plc

First published in Great Britain 2021
Reprinted 2021

Cover design by Charlotte Daniels
Cover image: Antony Gormley, *Feeling Material XIV*, 2005
4mm square section mild steel bar
225 x 218 x 170cm (unextended size)
Photograph by Stephen White, London (© The Artist)

A catalogue record for this book is available from the British Library.

A catalog record for this book is available from the Library of Congress.

ISBN: HB: 978-1-3501-5588-6
 PB: 978-1-3501-5589-3
 ePDF: 978-1-3501-5590-9
 eBook: 978-1-3501-5591-6

Series: Theatre Makers

Typeset by RefineCatch Limited, Bungay, Suffolk
Printed and bound in India

To find out more about our authors and books visit www.bloomsbury.com
and sign up for our newsletters.

To the next generation of theater artists,
who will emerge from these challenging times,
to make resonant theater.

CONTENTS

ACKNOWLEDGMENTS

Writing a book, much like rehearsing a play, "takes a village." I can only do so much. I write, but occasionally I lose perspective and I even lose the will to keep on going. In the writing of *The Art of Resonance*, as in life, I am grateful to my wife, Rena Fogel, not only for her genuine support, but also for her laser attention to detail and for constantly challenging me to clarify my thoughts and streamline the sentences and paragraphs. I am indebted to my colleague and frequent collaborator Jocelyn Clarke for his judicious suggestions about shaping and trimming the material. And I would also like to thank Anna Brewer, the Publisher at Methuen Drama, who took a global view of the book and proposed adjustments and rearrangements.

Introduction

I am writing this book from my little basement study in London in the midst of a global pandemic. Lockdown is the baseline existence, I watch as streets in the USA fill with civil unrest and dissent, an uncertain presidential race stumbles, hospitals and morgues are overtaxed, many businesses are on the verge of bankruptcy and most performance venues are shut down for an undetermined amount of time. At moments, the subject of resonance feels too rarefied, too distanced from the current realities. And yet, living in this gap, that the French so poetically call "un creux," can be fruitful because it is possible to stop moving around and to take the time to get in touch with what is essential. I am reminded that art and theater were originally created to get us through anxious moments while finding successful shapes to embody our present ambiguities. Significant cultural, social, and political changes generally happen in times of rupture, not in times of stability. Moments of disruption are crucial for artists. In uncertainty and even panic, art has a unique role to reflect what is happening in ways that can clarify and help us to eventually move forwards.

Our job as artists is to become consciously resonant to the world rather than alienated from it; to connect with others and to create the conditions for resonance among us. We do not do this by forcing our will upon the world, rather, we create the circumstances in which resonance might occur. In my own work as a director, both in theater and in opera, I like to imagine that for each new project we erect an old-fashioned

tent in which the event can occur. Tents are generally held up by poles at each corner and perhaps at the center. The first step in the construction of a tent is to plant the tentpoles into the ground for structural support. In the context of a rehearsal process, for example, each tentpole forms one of the cornerstones of the production, and all together they serve as the primary support system for the entire venture. Examples of tentpoles for a rehearsal process may be preparation, training, respect for others, a commitment to being present, readiness to take action, and so forth. Many different possibilities exist for what these tentpoles can be. Once sunk sufficiently into the ground, the tentpoles buttress the particular creative enterprise and ultimately deeply influence the experience of the audience by creating adequate spaciousness to accommodate the imagination. The same is true for other artistic processes, each tentpole forms a tenant for the overall system.

In Japanese Samurai culture, the Bushido code played an important role in the expansion of Asian art, Japanese values, tea ceremonies, and sword-making. Bushido later became the basis for teaching of ethics in Japan. The code, which drew inspiration from Confucianism, contained eight key principals or, in our case tentpoles, that warriors were expected to uphold: Justice, Courage, Compassion, Respect, Integrity, Honor, Loyalty, and Self-control. With these tentpoles in place, one could live an ethical life, a life of integrity.

In our current moment of rupture, wherein many of the building blocks of our social, cultural, and political systems have crashed to the ground, I feel compelled to carefully examine the pieces and decide what to reconstruct and what to discard. What are the tenets, the tentpoles, upon which to build the tents of the future? Despite the particulars of our circumstances, we humans continually seek resonance with the world and with other creatures. As artists, our task is to create the circumstances for that resonance to arise. This book is my attempt to examine our artistic allies in the path towards resonance and meaningful experiences. But before planting new tentpoles, first I must ask, once again, what are we doing, how are we doing it, and why?

1

On Resonance

On Resonance

I am writing in the midst of a pause. Theaters have been shut down for an indeterminate amount of time and no one knows what the future holds for the art of gathering-together-to-experience-performance. In this current moment of empty space, I return to the director Peter Brook's work, to his initial writings, for guidance. Over the years, his books of essays have been a model for my own writing.

In 1968, Brook began his seminal work *The Empty Space* with the following words: "I can take any empty space and call it a bare stage. A man walks across this empty space whilst someone else is watching him, and this is all that is needed for an act of theater to be engaged." The book fomented a revolution in the theater. Derived from a series of lectures begun in 1965, *The Empty Space* was a blunt assessment of the theater's failures and deficiencies and a call for change that was forthright, informed, and rebellious. It felt novel. Although the more conservative theater world resisted, the book nevertheless became an invitation to make the antiquated stage relevant again and ushered in an era of radical experimentation and deconstruction in small black box spaces, while exploring the classics in an intimate relationship to the audience.

Brook extended an invitation to theater makers to strip away the overabundance of stuff strewn across the stages; the

diversions, the excessive scenery, and the noise. The "deadly theater," as he called it, was in a rut, overly jacked up on sound, money, and music, all which was keeping audiences from experiencing, feeling, listening. In other words, the clutter in the theater space was *preventing* resonance. He proposed a search for what is essential in the theater and wrote, "We have largely forgotten silence. It even embarrasses us; we clap our hands mechanically because we do not know what else to do and we are unaware that silence is also permitted, that silence also is good." The final chapter, "The Immediate Theater," proposed a theater that "asserts itself in the present," where an audience reacts to what is actually happening on the stage. The responses are different every time because the audience members are different, and it is impossible to predict their feelings, understandings, and behavior.

> Theater exists so that the unsaid can breathe and a quality of life can be sensed which gives a motive to the endless struggle.

> PETER BROOK

The Empty Space spoke to its time, its particular moment. And yet, the essence of the book, the "author's message," connects across the forty-some years since its publication. The message is: the essence of good theater is the human connection. During this current moment, 2020, this year of suspension and upheaval, a great deal of noise is happening all over the internet. Zoom performances, readings, dance, and concerts abound. And yet, personally I resist this noise. What is lacking, for me, is resonance.

What is Resonance?

The *Oxford English Dictionary* defines resonance as "responding to vibrations of a particular frequency, especially by itself strongly vibrating." Resonance is what ripples and

radiates; one energetic being influences the vibrations of another. If something has resonance for me, it typically also implies that it has a special meaning or a particular importance for me through its connections to my own life and experiences.

Humans are resonating bodies that vibrate and fluctuate and each of us gains our identity, a sense of who we are, through the quality of our relationships to experiences outside of ourselves. In order to adapt effectively to our changing circumstances, we require stimulation. No good can be achieved by shutting oneself off from the world or from the environment because exposure to discomfort and dissonance is as vital to our development as our need for food and water. We become forceful human beings only through our processes of interaction with the world, starting with our own families and communities and then moving outwards. But there are no guarantees. The quality of our lives and the impact of our work cannot be predicted by the options made available to us or by the amount of resources or budgets afforded us. The impact is contingent upon the way the work resonates with our audiences and then spreads out into the world.

Theater and Resonance

Until recently, I assumed that the job of the theater was to plant lasting memories in the minds of audiences. I thought that the sign of a successful production is the enduring memories, literally the proteins, created in the minds and bodies of the audience in the heat of a performance. If the theater were a verb, I thought, it would be to *re-member*, to put the pieces back together again. But then my colleague Leon Ingulsrud, who was thinking a great deal about memory loss due to a family member's struggle with Alzheimer's, challenged my assumptions by asking me how the theater might be beneficial to those without the capacity to remember. What about people who have trouble forming memories?

Stymied, I had to ask once again: What should a play or an opera *do*? What is the sign of a successful production? What matters most in the experience of theater and how that impact can be measured? I started to think about my own formative experiences in art, performance, and literature. And this led me to consider more deeply the role of resonance.

Since I was a child, I have loved to read. I mostly read nonfiction. I read biography, science, and history. I read about religion and I read theoretical writings about art and performance. But I also forget a great deal of what I have read. I forget the facts and I even forget what triggered the specific insights that happened while reading. Content seems to slip away. Sometimes I forget that I have even read certain books. This forgetfulness used to bother me. But I now realize that the experiences that happen *while* reading, the insights and the ensuing emotions are the point. The act of reading attunes me to new channels, adjusts what I pay attention to and changes the patterns and frequencies of my day-to-day life. Reading has, in large part, transformed me and made me who I am and who I am still becoming.

Perhaps, like reading, I thought, the most successful theater experiences, indeed the great art experiences, generate *resonance* as well as memories. The reverberations engendered in the moment of an artistic encounter can have a profound effect on the body, on neural pathways, and consequently upon one's actions in the world, and subsequently, in the world at large.

Generally, my decisions about whether or not to take on a new project are based upon my own resonance with the specific material. In opera, the choice is often dependent upon my feeling for and response to the music. In theater, the play or project must literally provoke a *frisson de corps*—or goose bumps—in my own body. I think of my body as a barometer or as a tuning fork. I pay careful attention to the gradations of reverberations, the resonances, that arise when considering a new venture.

Good Vibrations

Resonance suggests vibrations that synchronize. When fireflies of a certain species come together in large gatherings, they start flashing in sync. A recent study has shown that an audience's heartbeats in the theater sync-up as well. When I visit a museum and find myself drawn to certain works of art, I feel myself tuning into the particular frequency of the artwork. Prayer can connect the internal world with the external through vibration. The resonant voice of a singer can set up sympathetic vibrations in my own body. Looking at old photographs that have emotional attachments causes resonance. Why does a particular play, painting or piece of music resonate with me, and others do not? If I am a tuning fork, do certain external frequencies create particular vibrations in me? And do these vibrations then set off a chain reaction? Do I walk away from a play, a painting or a piece of music better tuned? When I leave a museum after seeing an exhibition, or when I leave a theater after a performance, am I now tuned to a different frequency? "Everything in life," said Albert Einstein, "is vibration."

> She thinks about his words, hearing the truth of them. They resonate, as if a tuning fork aligned with the sound of her heart and gave it a voice.

KIMBERLY MORGAN

We inhabit a vibrational universe. Everything moves. Nothing is at rest and everything is energy at different levels of vibration. Even objects that appear to be stationary are in fact vibrating, oscillating, and resonating, at diverse frequencies. The term resonance, from the Latin *resonatia*, "echo," and from *resonare*, which means to "re-sound," or to "sound together," originated in acoustics. Resonance is a sound or vibration that happens in one object but is caused by the sound or vibration produced in another. In music, one string starts to vibrate and produce sound after a different one is struck. Most musical instruments

cause resonance, which is also defined as a quality of sound that stays loud, clear, and deep for a long time. It is worth mentioning that the decrease of resonance in musical instruments is called *dullness*.

In rehearsal we search for resonances between the actors, among the compositional elements in the space and in the musical nature of the text, the shifting qualities of tempo, repetition, and duration in movement and in sound. But ultimately, we are attempting to construct moments of shared resonance between the stage and the auditorium, between actors and audience, among bodies, objects, ideas, and moments of being.

Perhaps a successful theater experience is one which sets up resonances in the bodies and minds of both the actors and the audience in ways that do nothing less than alter the physiognomy of those present. The musical *Hamilton* had an uncanny resonance that spread widely. A production that does not achieve this oscillating resonance in the audience can, as with musical instruments, result in *dullness*. But then, a dissonant experience which is disturbing, unpleasant or even excruciatingly painful only occasionally results in resonance. Resonance is the opposite of alienation, which is the inability or impossibility to enter into a relation with another or to form a meaningful relationship of mutual understanding and interaction with the immediate surroundings or with fellow human beings. Alienation from one another and from the environment leads to stagnant systems, resonant only with a nostalgic image of the past and governed by domination and appropriation, a hegemony obsessed with accumulating resources and keeping out any unfamiliar or unwanted influences.

Morphic Resonance

In 2016, the Catholic Pope Francis visited Auschwitz-Birkenau and he chose to make the outing in silence. "I would like to go to that place of horror without speeches, without crowds—

only the few people necessary. Alone, enter pray. And may the Lord give me the grace to cry." In the case of a place of such suffering, is the resonance imagined or is it real? Do the walls of Auschwitz contain the memories of the 1.1 million people who were slaughtered there more than three-quarters of a century ago?

Do places retain remnants of what occurred there previously? Do theater buildings resonate with the memories of all of the performances that happened and are the imprints of all of the actors' bodies who tread the stage somehow present as well? Is a theater in the midst of a performance radically different than the same space when it is dark and empty? Does a company of actors collectively warp a space by creating immaterial architectures of sound and movement? When an actor walks into a room, does the room change?

British biochemist Rupert Sheldrake chose the words *morphic resonance* to suggest that memory is inherent in nature and that interconnections between organisms exist as well as collective memories within species. According to Sheldrake, nature is alive and vast networks of interconnections between organisms reverberate and exchange information across space and time. He wrote, "Natural systems, such as termite colonies, or pigeons, or orchid plants, or insulin molecules, inherit a collective memory from all previous things of their kind no matter far away that they were and however long ago they existed." He describes a Harvard experiment with rats that learned to escape from a water-maze, and he points out how subsequent generations figured out the same path faster and faster. After the Harvard rats had learned to escape more than ten times quicker, the experiment was launched in Edinburgh, Scotland, and in Melbourne, Australia and the rats tested there surprisingly started more or less where the Harvard rats left off. And so, the effect was not confined to direct descendants of the Harvard rats. According to Sheldrake, this ability of the Australian and Scottish rats shows morphic resonance rather than a transfer of information through genes.

In Sheldrake's conception, nature is alive and morphic resonance is the "influence of previous structures of activity on subsequent similar structures of activity organized by morphic fields." Morphic resonance enables past memories to permeate both space and time. Sheldrake also believes in the interconnection between humans and animals, especially dogs. Morphic resonance, according to Sheldrake, also accounts for how dogs know when their owners are coming home, how amputees can feel phantom limbs, and how people know when someone is staring at them.

No matter how much suffering you went through, you never wanted to let go of those memories.

HARUKI MURAKAMI

I lost count of the times that I have entered a room to find my wife, Rena, weeping amidst objects or photographs from her past. I watch how she gently and lovingly holds the objects that had once been touched by a cherished family member or gazes longingly at the visages of her children looking back at her from the many photographs. These artifacts create tremendous resonance in her body and serve as a stimulus to vast landscapes of emotion and memory within her.

Rena's relationship to her beloved objects is not only poignant but also instructive. The power of memory to stimulate resonance is visible and palpable; they are alive in her body as she holds these precious artifacts in her hands. We contemporary artists have somehow swallowed the party line that our job is to express ourselves and to create our own singular, distinctive signature. We are supposed to show how unique we are, and how our work is novel and hip. And we are often praised or criticized by our ability to express ourselves with panache. But perhaps self-expression, in itself, is a dead end that can lead to solipsism and narcissism. Perhaps rather than self-expression, our intention, or one of the tenets—or tentpoles—of our work, can be to create the conditions for resonance.

Transformation

Resonance involves transformation. Each meaningful work that we make, in addition to being *about* something, offers the audience a pathway *to* resonance, to an inherent essence that people can connect with in a deeply personal way. Catharsis can be defined as "shining light into dark places." Resonant art awakens and casts light into the hidden realities of our lives and of our world. In order to perceive these hidden realities, our job as artists is to become resonant to the world as opposed to alienated from it. Resonance is not consonance. Resonance is not agreement; it exists in between consonance and dissonance and does nothing less than challenge one's own identity and assumptions about what it means to be human.

Creating space for the realization of certain brutally present truths about the world is key to changing our current political and social landscape. Recent events have made it abundantly clear to me that I was born into a deeply racist society. I knew it and yet I did not *know* it. My own grasp of the depth of pain around the history of slavery, the subsequent Jim Crow era and our current system of incarceration and economic inequality required a pandemic and an emotional uprising after the brutal murder of a black man named George Floyd in Minneapolis while in police custody. The subsequent roiling protests in solidarity with the Black Lives Matter movement set off an avalanche that has no end in the current climate. Many of us, and I count myself as one, were shielded from the daily realities that face the BIPOC community, and we were protected from their experiences by our own white privilege, the veiled realities of a pre-existing structural racism, and even our own good intentions. And now, many of us are at last becoming aware of the extent and seriousness of these endemic conditions and there is no way to look away anymore. Truth resonates. Wave upon wave of revelations, disclosures, and eye-opening statistics reveal the systemic violence and the intergenerational trauma perpetrated against the BIPOC community that continues on a daily basis. Living in the

discomfort of these revelations is a vital aspect to any personal or meaningful systemic change.

Political movements are successful only when they converge with an aspect of resonance. The words "I can't breathe" have been echoing around the planet and have now, finally, hit a widespread sympathetic nerve. A man on the precipice of life and death pleads for air. The impact of the cellphone-recorded physical violence and those three real and palpable words are shocking, inescapable, and reprehensible. Those three words also became a powerful and meaningful metaphor for powerlessness and social injustice. The primal human fear, suffocation, not being able to breathe, speaks volumes and resonates with each of us. The metaphor of "I" becomes, in empathy and solidarity, a "we." We empathize instantly with the inability to breathe and we can each feel the personal terror of being in that condition. From the trope, "I can't breathe," an outpouring of empathy and outrage motivated millions to exit their homes after a long confinement and take to the streets in protest against brutality, social inequality, and merciless police practices. A political movement can hit a formidable chord and the reverberations are exponential.

What I need y'all to do right now at 16 is come up with a better way. 'Cause how we're doing it, it ain't working. He angry at 46, I'm angry at 31. You angry at 16. Y'all come up with a better way, 'cause we ain't doing it.

CURTIS HAYES

Wavelength

Limbic resonance suggests that the capacity for sharing deep emotional states arises from the ancient limbic system of the brain. Our brain chemistry and nervous systems are measurably affected by those closest to us and our systems synchronize with one another in a way that has profound implications for

personality and lifelong emotional health. Empathic resonance proposes that our nervous systems are not self-contained but are demonstrably attuned to the people around us, especially those with whom we share a close connection. From earliest childhood, our brains link with those of the people closest to us. We become attuned to each other's inner states. As we move through the world and interact with others, we tune ourselves to those that we spend time with. When vibrations resonate with similar vibrations, they harmonize. For a successful relationship, whether in art or with other people, I have to attune, as best as I can, to another person's frequency. If someone is on my wavelength or if I am "in tune" with them, resonance occurs.

Resonance and being Present

Speaking about resonance on Zoom in conversation with young Southern California directors, one of the participants asked about the difference between resonance and presence. As with any good question, this one caused me to pause. "Well," I said slowly, "you cannot experience resonance without the ingredient of presence." When I visit a museum and I am in a hurry, there is little chance that I will experience resonance. In order to connect, I have to stop and be present in the force field of a given work of art. Being present means not being lost in thought about some pressure of the day, not planning my next steps. Being present means meeting the moment, physically, emotionally, and perceptually in that particular place, at that time. Only then can something start to happen; some vibration may transpire.

The resonances, the syncing up, that happens in the course of my own life, in turn, influence the quality and trajectory of my experience of living. It matters with what and with whom I reverberate. If a piece of music truly reaches and touches me, if I can be present enough to receive it, I can feel my organism shift incrementally. But in order to resonate with something, I

have to attend fully to it, with an openness to being affected, influenced, and literally moved. Sometimes I re-sound to a speech or to a book or a person or an animal, or an object or a work of art. I can feel the excitement, the *frisson de corps*, that rises up in my body as the encounter begins to take its effect and I feel connected to the living network of the world and the roots beneath the surface.

To be on the receiving end of resonance, to be an audience member at a performance, requires a certain disposition, a specific way of relating to the world. I must be ready to reach out, to hear the call, and be open enough to be altered by the interaction. It is not an echo chamber; rather, resonance is an encounter with something from outside of myself which may be irritating or unsettling, but which calls upon me to respond. Resonance is not only an intellectual idea, it is also an embodied experience, involving perception, sensation, cognitive function, imagination, and feeling. Resonance and dissonance need to be in an acceptable state of balance. Something that simply makes me laugh or cry is not necessarily resonance, rather it is emotion. Emotion is a strong sensation within myself, but in itself it is not necessarily an encounter with something that I must answer to. Resonance sets up the expectation of questioning and answering and refers to the connection between the subject and the world; reciprocity and transformation.

For many years, the composer John Cage lived in a building on Sixth Avenue and 18th Street in Manhattan where, even with the windows closed, his apartment filled with the loud and ever-present hum of traffic. At first Cage considered the sound annoying but then he decided to change how he received or perceived the noise. By remaining present with it, he discovered that the constant sound rising from the avenue through his window subtly changed but nevertheless had a sort of homogeneity that he could enjoy. "If you listen to Mozart and Beethoven, it's always the same," he claimed. "But if you listen to the traffic here on Sixth Avenue, it's always different."

Resonance in Rehearsal

A rehearsal process entails building up resonance and meanings within the space and time set aside to prepare to meet an audience. The individual and collective contributions of the actors and the design team engage the consistent enrichment, compression and concentration of patterned ideographs, gestures, actions, sounds and words impressed upon the space and time through physical and emotional heat and energy. The repetition of scenes from rehearsal to rehearsal stores up memories and thickens the air between actors and their environments. With success, the paths carved in space over time in rehearsal become increasingly meaningful and thereby powerful for the audience. On the other hand, a bad rehearsal process can build up confusion and lack of clarity in the production.

Most actors recognize moments onstage when their own volition recedes, and they start to follow a power that has come into play. And here the process of unfolding takes over. The actors' resonance can be contagious and transferred to the audience and vice versa. Audiences, in the heat of a performance, suddenly feel that they no longer need to concentrate in order to follow the narrative. In that moment, they become part of the aesthetic experience and have joined with the flow of the performance. Something is *at work*: resonance. This now shared journey is what sociologist Helmut Rosa calls "collective resonance."

My job as a director is to awaken resonant channels to others. But I must begin by creating the conditions for resonance in myself. To begin with, I must be open to being affected, to being influenced. How am I being with others? How am I listening? How am I inviting resonance? This is not about being true to myself and I should not expect any kind of affirmation of my own authenticity in the process. Resonance involves transformation and is tied to openness, to wanting to be affected, and also the willingness and readiness to answer a summons; I am called upon to respond to something outside of

myself. The ensuing intra-actions create a transformation within me.

In any field, resonance implies evoking a response. In physics, oscillations can build up rapidly to such high levels that if some are not removed, objects begin to break, causing glasses to crack, bridges to collapse, and even helicopters to burst into pieces. Political rallies that build up oscillations and resonances in the audience that release permission for violence and the celebration of intolerance are clearly dangerous. And this is a frightening recurrent development that we must watch closely. Perhaps it is instructive to look at resonance in the theater from these other contexts. If our shared objective, as theater makers, is to create stage moments that resonate with the audience, we are also responsible for the intensity and quality of these oscillations, this resonance.

2

Cast Down Your Bucket

In 1947, a 33-year-old high school teacher named Nina Vance was determined to start a new theatrical venture, but she only had $2.17 in her wallet. She emptied the contents of her handbag onto a table and declared that with this money she would create a new theater. Postcard stamps at the time cost one penny apiece. She and her friends addressed 217 postcards inviting people to gather at a particular time and place to discuss starting a new theater company. And this is how the Alley Theater in Houston, Texas, now one of the nation's leading regional repertory theaters, came into existence.

The history of human innovation is the history of using what is available in the present moment to create something new. The ramifications of the current paradigmatic shift that started with the Covid-19 pandemic in 2020 are social, cultural, and political. The resulting turbulence in our social, cultural, and political landscape is monumental and within this flux and change, we are called upon to innovate. Are we going to reconfigure our social systems? Are we going to reinvent the theater? And if so, how?

Finding a Place

"Cast down your bucket where you are," said Booker T. Washington in one of the most influential speeches in American history. The bucket motif represented a call to promote

personal strength and diligence in order to rebuild the South following a brutal Civil War. He felt that people should make the most of any situation that they find themselves in. In this case, he meant African Americans should look for economic opportunity in the South instead of moving to the North. He proposed that the two races look to one another for mutual advancement.

As a young theater director trying to make it in New York City in the early 1970s, my idea of paradise was to live in New York, find a writer, put together a theater company, direct plays, and flourish. I was definitely ambitious, self-centered and full of the desire to distinguish myself within the wild frontier of the downtown arts scene of the time. But the doors to all available directing jobs seemed shut securely in my face. Even knocking on the doors felt futile. I was young and untested and at the time there were very few female directors in the theater upon whom I could model my own assault upon the citadel.

And so, rather than trying to enter paradise directly, a path that looked to me to be a corporate model specifically created for men, I eventually found my way into the heart of the theater world by moving circuitously around to the back. I put my bucket down exactly where I was standing and pursued what seemed to be the available option at that time: to self-produce plays in my own neighborhood. I asked for favors from my friends, my contemporaries who were also trying to make their way in a challenging urban environment. I talked young actors into joining me in making theater in shop windows, parking lots, and abandoned school buildings. Together, with a shared mission, we managed to create distinctive theater with no money and within the given confines, restrictions, and conditions of downtown New York. These given circumstances, which required us to make work in non-theatrical spaces, led us to create what is now called immersive or site-specific theater.

At the time, my choices felt intuitive rather than strategic. Rather than using my energy and frustration to knock on

the front door, demanding access from the existing hierarchy, I stood firm. I looked around where I was standing and started to make theatrical journeys for audiences within the context of the immediate environment. The paradise that I had imagined, the life of a working director, came about eventually via this circumnavigation. In order to enter paradise, I had to go through the back door, which was exactly where I stood.

Doorways

A true revelation, I am convinced, can only emerge from stubborn concentration on a single problem. I have nothing in common with experimentalists, adventurers, with those who travel to strange regions. The surest, and the quickest, way for us to arouse a sense of wonder is to stare, unafraid, at a single object. Suddenly—miraculously—it will look like something we have never seen before.

CESARE PAVESE

Many years later, and in conjunction with SITI Company's production of *Room*, based upon the writings of Virginia Woolf, I participated in a panel discussion with Washington DC's Arena Stage Artistic Director Molly Smith and Tina Packer, the Founding Artistic Director of Shakespeare and Company in the Berkshires. The discussion took place at the University of Maryland. Our task, in the spirit of Woolf, was to address the notion of women carving out careers in the arts. As the public conversation proceeded, I suddenly realized that all three of us—Molly, Tina, and I—had each found our places as directors in the theater by going through the back, rather than the front door.

When Molly Smith graduated from American University with an MFA in directing, she and her then husband transported fifty old theater seats back to their hometown of Juneau, Alaska where she had gone to high school, with the

intention of starting a theater company. In Juneau, a city with absolutely no tradition of theater, she founded the Perseverance Theater and singlehandedly created an appetite for theater in Juneau. Tina Packer left the UK and the male-dominated Royal Shakespeare Company where she had started, to found her own domain in the hills of western Massachusetts. Although she is no longer the Artistic Director, today Shakespeare and Company performs Shakespeare as well as new plays of social significance, reaching over 75,000 patrons annually. And it also conducts professional training programs and Company members work in the school systems. My own path in the downtown theater scene of New York City was rooted in my observation that the corporate ladder to success in theater was constructed for men and quite out of my reach. Instead of trying to compete for a place with the men on their ladder, I turned in another direction and self-produced work on the streets where I lived, in lofts and in non-traditional spaces around Manhattan and Brooklyn.

Molly Smith, Tina Packer and I, each in very different ways, eventually learned to negotiate the theatrical terrain and find our distinctive places and voices within that world. I imagine that there are those who believe that the three of us, each in our own way, have "arrived." But I would not have become the theater artist that I am today if I had knocked incessantly upon what seemed to be the front door. I did not spend my time networking or assistant directing. Instead, I stood firmly where I already was and began to direct plays for downtown audiences.

Misconceptions are unavoidable now that we've eaten of the Tree of Knowledge. But Paradise is locked and bolted, and the cherubim stands behind us. We have to go on and make the journey round the world to see if it is perhaps open somewhere at the back.

HEINRICH VON KLEIST

In his seminal 1812 essay *About a Marionette Theater*, Heinrich von Kleist wrote poetically about Adam and Eve's

fall from grace and how they were ousted from the Garden of Eden. As a result of their sin, humans lost their unity with God and, consequently, paradise became locked and bolted to all of us. Kleist proposed that however desirous we may be to do so, there is no "going back" to a state of primal innocence and unity. We are neither god nor puppet but rather something in between.

In contrast to the front door, a back door can be understood as an alternative, unofficial point of entry. In past centuries, back doors were used by servants. In rural areas, visiting neighbors entered through the back door in order to avoid carrying dirt through the front door which was reserved for more formal visits. Today we may think about the back door to a restaurant where deliveries are received and the wait-staff smoke on their breaks. A door can be a symbol of either opportunity or of imprisonment. In religion, mythology, and literature, a door is often used to symbolize the passage of one realm to another. The metaphor of moving through a door implies entering new territory, engaging in new opportunities or transitioning from one space to another.

Through years of constant negotiation and navigation, I learned that the creative process itself also requires great facility with doorways. Although every new endeavor demands the kind of intense will and desire that can beget strength and energy, there are crucial steps in the creative process that simply cannot be accessed directly, that cannot be forced. Rather than insist or coerce, I must *cast down my bucket*, have patience, and trust that a fragile notion, a hint or a hunch will lead to an unexpected entrée. There are periods in each process that I must maneuver tangentially in the vicinity of my prey like a hunter. I lie in wait. I pace in circles until an opening occurs.

Just do your work. And if the world needs your work it will come and get you. And if it doesn't, do your work anyway. You can have fantasies about having control over the world, but I know I can barely control my kitchen sink. That is the

grace I'm given. Because when one can control things, one is limited to one's own vision.

<div align="right">KIKI SMITH</div>

We start by *casting down our bucket where we are*. The next step is to look carefully at the immediate environment and the given circumstances. What and who is present; what is at hand and available? With these resources we begin to construct something new, something with meaning, usefulness and, when the circumstances are correct, something that resonates.

Kludge

Computer scientists and evolutionary neuroscientists have popularized the word *kludge* (alternately spelled *kluge* or *klooj*), to embody a clumsy or inelegant solution to a problem that also gets the job done. The word is perhaps derived from the German or Yiddish *klug*, meaning clever, or possibly it comes from the Scottish word for an outdoor toilet (*cludgie*).

Whatever its origins, perhaps the most well-known *kludge* in the scientific sense of the word was the device that rescued the imperiled astronauts of Apollo 13. An accident crippled the spaceship more than 200,000 miles from earth, severely damaging its two main oxygen tanks. But having enough oxygen was not the issue, rather it was having too much carbon dioxide that came from the astronauts' own exhalations which threatened to kill them.

There is a short scene in the Hollywood film *Apollo 13* in which a group of engineers in Houston hastily gather in a conference room to come up with a solution to the problem of leaking oxygen and toxic carbon dioxide in the astronauts' capsule. After dumping a box full of flimsy objects onto the table, an engineer says, "I don't care what anything was designed to do. I care about what it can do. We gotta find a way to make this . . . fit into the hole for this . . . using nothing

but that." The engineers went to work, using only the type of equipment and tools that could be found onboard, including plastic Moon rock bags, cardboard, socks, suit hoses, and duct tape. They had to work quickly, and they could only use what was available on the spacecraft. They succeeded and their ingenuity ended up saving the lives of the astronauts.

Some evolutionary scientists describe the human brain as a *kludge* because of the way it originated as an ill-assorted collection of parts assembled to fulfill a particular purpose and then altered and adapted to changing circumstances. The human brain was developed over time in order to make useful predictions about the future so that we may successfully negotiate an increasingly complicated environment. The brain learns from each life encounter, forming models in order to confront and succeed in complex surroundings. We use what we know to fend off danger and harvest reward.

Perhaps using the notion of a *kludge* is a good way to examine the proclivities of postmodernism. Of all the historic, artistic, and scientific periods, our own era has probably most enthusiastically embraced the idea of making new things out of old ones. Postmodernists tipped over the fortress of hierarchical principals of modernism, classicism, romanticism, and so on, and picked up the pieces, bit by bit, looking anew and with great interest at each building block as a separate phenomenon. Without a singular, dominant point of view and declaring that no one part was more important than the next, the postmodernist aesthetic evolved.

In the theater, one of the recurring challenges is the necessity to strip away the meanings that have calcified over time from past productions, and to loosen the expectations that audiences bring with them. For the artist, the process begins with how you look at what is immediately around you. *Cast down your bucket where you are.* Then look and listen. Be curious. Use what is at hand. My own tendency is to incorporate whatever object is present into the composition of the play. A lopsided chair easily becomes the perfect tool for storytelling, for aesthetic arrangement, and for metaphor. At the beginning of

any new project, scenic designers who know me well are trepidatious about what is already present in the rehearsal hall. They often ask the stage manager to remove any excess furniture before the first rehearsal.

At the Center of My Own Party

One's destination is never a place, but a new way of seeing things.

HENRY MILLER

Now that we are looking around to see what is available, the next step is to apply the heat of genuine curiosity, which is both an action and a useful tool. And it can be cultivated. Being authentically curious about where you are and who you are with invariably opens up new doors and vistas. Our own inquisitive nature is the trowel that excavates the surface and with it we can dig and unearth rich returns. And curiosity produces a warmth that can cut through doubt, resentment, assumption, tiredness, regret, boredom, and impatience. Following the heat of interest, valuable details emerge and one's ability to make connections among various pieces of information increases. In these moments, try to imagine that where you are is always the center.

During the late 1990s SITI Company regularly led two- and three-week summer workshops in Los Angeles during which time we had the pleasure of getting to know many members of the local theater community. Generally, SITI stayed at the Highland Gardens Hotel in Hollywood not far from the Magic Castle Hotel. Highland Gardens is a rather seedy consortium of buildings arranged around a liver-shaped swimming pool, boasting that Janis Joplin died of a heroin overdose in 1970 in room 105.

Each room at Highland Gardens has a little kitchenette, a bedroom, and glass sliding doors giving out onto a little balcony terrace. With luck, you score a room that faces

inwards, towards the pool rather than outwards onto the busy street. One summer during our residency I enjoyed a room overlooking the pool and every evening after work I sat outside on the balcony. Lots of Los Angeles theater luminaries dropped by to visit me on my little balcony and we talked, laughed, and drank late into each night. I delighted in these encounters and came to think of each evening as if it were my own Public Access TV program. At the time, Public Access was a non-commercial system of broadcasting on television channels made available to independent or community groups. Of course, there were no cameras on my little balcony and also no audience, but I liked imagining that everyone who came to visit my balcony was a guest on my public access show.

My feeling about being the host of my own Public Access TV program was the opposite of the wide-ranging state of FOMO ("fear of missing out") that now permeates our social-media-saturated contemporary culture. Rather than missing out, at Highland Gardens I felt that I was the center of the universe. Where I go, I thought, is what is happening. Where I *cast down my bucket* is the center. To cultivate this attitude, all that was required was a small shift of outlook and suddenly it was others, not me, who were missing out.

When I imagine that I am the host of my own Cable Access TV program, I feel momentarily that I am at the center of the universe. But concurrently I also understand that, in fact, there is no center of the universe. There is only the particular universe of which I am the center, and the universe of which you are the center and so on. And we are all profoundly entangled. There is no place where I can stand idly by while someone else stands at the center. We make space for one another. I am inexorably interconnected to the infinite numbers of parallel universes.

When preparing to direct a play, I often feel that everywhere I go messages are laid out just for me. Everything that happens to me, every conversation, every newspaper article, every book, and each encounter seems relative to my study and becomes helpful fodder for the production. In the midst of this preparation, I feel as though I am an open vessel waiting to be

filled with ideas, images, sound choices, and insights. I am on a treasure hunt and insight is just around the next corner. I allow myself to take plenty of detours and often feel that I am caught up in an adventure.

Get Curious

I have no special talents. I am only passionately curious.

ALBERT EINSTEIN

The itch, the impulse to seek out new information and to make discoveries is a basic human attribute; a motivational desire that stems from an appetite or a passion for knowledge, information, understanding, and new experiences. Not only is curiosity linked to exploratory behavior, but it is also tied to the reward system of the brain. When one's interest has been aroused, the reward system is activated, which in turn strengthens synaptic connections. Positive emotions are ignited by discovering new information. This hunger for information, for insight, is a physiological need in both humans and in many animals and is related neurologically to the same synaptic pathways as a hunger for food.

A study published in *Neuron* magazine reported that as we become curious, our brain's chemistry changes and this, in turn, helps us to retain information and to even increase our ability to learn as well as to remember. MRIs used in these studies show that when I am curious, the activity in the hippocampus, which is the area that is involved in the creation of memories, surges. When this circuit is activated, the brain releases dopamine, which instigates a natural high. The dopamine plays a role in enhancing the connections between cells that are involved in learning. When my curiosity has been piqued, the area of my brain that regulates pleasure and reward lights up. The part of the brain that energizes me to go out and seek rewards is the same as when I am curious.

In order to be present and at the center of my own party, I know that I have to open up and let the game come to me. The ability to cultivate both curiosity and interest is the key to a rewarding life. But I know that in order to be successful in this endeavor, I must get out of my own way. When experiencing doubt, frustration, impatience or uncertainty, I tell myself to get curious. When I try too hard or want too much, I miss out. "Be like water," said Bruce Lee, who continued, "You put water into the cup, it becomes the cup, you put water into a bottle . . . be water, my friend." Inspired by Lee's instruction, I try to be present and remember that ultimately it is not me who makes anything happen. Water seeks out its own level. Without trying too hard, I want to take off the filter and open wider to the world. I want to accept what is and experience it directly.

Commit and Adjust

If a point of view is to be of any use, one must give oneself to it totally, one must defend it to death. And yet, at the same time, a little interior voice whispers to me: "hold on tightly, let go lightly."

PETER BROOK

Having *cast down our bucket where we are*, having looked around to see what is available to work with, having applied the heat of genuine curiosity, the next phase in the journey towards resonance is to commit fully and, simultaneously, to be able to adjust.

The Taoists describe the art of life as the art of constant adjustment to the current surroundings. Because our own conditions are currently shifting so radically, nothing could be more central to a successful creative endeavor than the ability to adjust to what is happening now. But this has always been true. A painter continually adjusts to the previous strokes on the canvas. A musician in a jazz band adapts to the room and

to the choices of the other musicians. A theater artist is sensitized to the constant spatial and temporal changes that are taking place from moment to moment. Clearly the practice of adjustment is an essential ingredient in the artistic process.

At each moment in daily life, consciously or unconsciously, we choose an attitude in relation to the world around us. Then, based upon what we are receiving back from our immediate surroundings, we shift our attitude, shift our stance, and shift footing. We alter our position in relation to others and to the circumstances in which we find ourselves. We can change our frame of mind, and we can also change the way we think. We switch codes in order to meet others on a more level playing field or to get approval or to create distance. Physically and vocally we switch codes by changing the speed, altering the tempi, pitch, rhythm, stress or tonal quality or by making unexpected spatial choices. Nothing could be more central to a successful creative process than the ability to adjust to what is happening in the moment. The painter continually adjusts to the previous strokes on the canvas. Clearly a dedication to the deliberate practice of adjustment is essential to artistic training.

And yet, in the midst of split-second adjustments one must also concurrently summon the courage to make bold and committed choices that exude presence and meaning. How is it possible to execute fully committed choices and simultaneously be open and available to change? This is the paradox that lies at the heart of all art making.

Every situation contains a void. In order to embody the paradox of control and relinquishing control simultaneously, it is necessary to learn how to make space for others by looking, both internally and externally, for the void. Is it possible to allow space for others without losing one's own position? The space created by the situation matters far more than the situation itself. Concentrate upon the empty spaces between things. Is it possible to make space inside oneself and in the space that you share with others so that they might join you?

To adapt to the specific situation, people change syntax and vocabulary. The way a person speaks to an employee, to a boss or to a child, changes. Linguists call these adjustments code switching. The theater also requires actors to be able to code switch with alacrity and demands an appetite for and dedication to split-second adjustments and change. The theater's dramatic force is animated by the symphony of code switching that happens consistently in social situations. The motivations and impulses that stimulate code switching originate the human desire to adapt to variable social situations. This human proclivity to adjust can, through dedicated practice, become visible and give us meaningful and resonant moments of theater.

Temenos

To write a work of genius is almost always a feat of prodigious difficulty. Everything is against the likelihood that it will come from the writer's mind whole and entire. Generally material circumstances are against it. Dogs will bark; people will interrupt; money must be made; health will break down. Further, accentuating all these difficulties and making them harder to bear is the world's notorious indifference. It does not ask people to write poems and novels and histories; it does not need them.

VIRGINIA WOOLF

In *A Room of One's Own*, Virginia Woolf writes about the necessity for women writers to find and occupy their own space; a room where they might find spaciousness and agency. In addition to the need for an actual room, the title also refers to an author's need for poetic license and the liberty to create literature of substance. Completing the book in 1929, Woolf's advocacy for the kind of spaciousness that is at once physical, financial, mental, emotional, and cultural became a battle cry for women artists. Her plea for breathing space, or

legroom, feels to be a call for the room in which resonance can arise.

The ancient Greeks coined the word *temenos* to indicate a piece of land, sometimes a grove or a spring, usually near a temple or sacred enclosure, set aside to create a sanctuary. The word *temenos* in Greek literally means "cut off" and signifies an area marked off from common usage or daily activity, a safe or protected space, isolated from everyday living spaces. *Temenos* was a receptacle or field of a deity or divinity. It was also a place where drama was performed for the purpose of spiritual, emotional, and psychological transformation. For the ancient Greeks, it was important not to pollute *temenos* with daily concerns and habits and for that reason, the area was sectioned off from the rest of the world. The boundaries not only served to contain energy, they also insured human access to the spirit of the place.

It can be useful to think of *temenos* as an emotional or psychological space as well as a physical one. *Temenos* was one of Swiss psychiatrist Carl Jung's favorite expressions, which he employed to refer to the spellbinding or magic circle that acts as a "square space" or "safe spot" between analyst and patient where mental work can take place. Jung described *temenos* as "a means of protecting the center of the personality from being drawn out and from being influenced from outside." He believed that the human need to establish and preserve *temenos* is indicated by dream images, drawings, and mandalas. For him a mandala is also *temenos*, serving as a holy place for the observer. The center is protected by the design of the mandala. The symbol of the mandala has exactly the meaning of a holy place, *temenos*: to protect the center of the observer. But Jung imagined *temenos* not only as an object or place but also as an experience, a virtual, meditative space that can be inhabited by the mind, signifying the inner space deep within us where soul-making takes place. The center of a person's personality requires periodic protection from being drawn out and influenced by the outside. Jung imagined the "circled square," in which an encounter with the unconscious can be had, as a

symmetrical rose garden with a fountain in the middle. In this space, dangerous unconscious contents can safely be brought into the light of consciousness. In this way, in the shelter of *temenos*, his patients could meet their own shadow.

Many years ago, my T'ai Chi Chuan teacher, Jean Kwok, made a trip to Hong Kong. On her first morning in the city she walked into a nearby park to practice her form. The large park was filled with many separate groupings of people and individuals moving fluidly through a wide variety of styles of T'ai Chi Chuan. Developed by different families in China over the course of the centuries, T'ai Chi features literally hundreds of distinctly different forms. Jean walked around the park observing the variations in form with great interest. After a while she found an area that felt right for her own practice and she began to move through her form. During the course of her practice she became aware of a man standing nearby watching her. When she finished, the man approached her and said, "You are doing my form." Jean was surprised because even within her Yang family of T'ai Chi Chuan there are countless styles that vary in length, number of moves, breadth of limb extension, and attack. The chance of meeting someone who practiced her own style was slim. Then the man told her that he had been waiting for her to finish because she had chosen his very own practice spot.

Cultivation

I search for *temenos* in my own life. I am drawn to boundaries for the soul, where time and space can be set aside to create islands of consciousness and safe zones for renewal. I consciously seek places where I can *cast down my bucket* away from the busyness of the world where a certain spirit can breathe life back into my activities. For me, *temenos* is the refuge, both physical and psychological, that allows for the practical regeneration of the soul, allowing me to return to the world of constant connection with greater vitality. For ten years,

essentially during the 1980s, I lived in a tiny fifth-story walk-up apartment over a paint store in the East Village of Manhattan. In the midst of forging a career in the downtown theater world, I needed a place where I could escape, a secure and sheltered space where I could replenish. The apartment became a refuge and I cherished every moment that I spent there.

In 2000, I bought an 1850s farmhouse in the northern Catskill Mountains. This space, over time, has become sacred to me as a place of regeneration and restoration, providing *temenos* for my family and for me. The existence of this space allows us to move fluidly and consciously from one environment to another. But while it was possible for me to buy a house, *temenos* exists outside the sphere of attainment and spending. It cannot be bought; rather, it must be cultivated. When places are acquired only for function and practicality, *temenos* suffers. In the tiny town in the Catskill Mountains, little by little, over the years and with vigilance and care, the house has become spaciousness itself.

Every morning, whether upon a small spit of land, a corner of a room or in a rehearsal studio, I mark out a space and move through a T'ai Chi Chuan form. Thanks to my teacher Jean Kwok's many years of careful and thorough instruction, I learned to construct *temenos* within small pockets of time and space each and every day when I begin my practice. I am able to enjoy the priceless spaciousness that is available to each one of us.

Man cannot discover new oceans unless he has the courage to lose sight of the shore.

ANDRÉ GIDE

Getting Lost

Finally, having *cast down our bucket where we are*, having looked around to see what is available to work with, having applied the heat of genuine curiosity, having nurtured the ability to commit fully to the journey while simultaneously

being ready to change, one must embrace the necessity of losing oneself.

And yet getting lost runs contrary to my nature and to the way that I was raised. Growing up in the Navy, every year or two my family moved to a new state or country. If, by the second or third day in the new environment, I was not able to point out north, south, east, and west, if I did not interiorize a map of the land, if I did not know how to negotiate the streets and geography, my brothers and my parents would ridicule me. I grew up scrambling to study maps, to understand the lay of the land, and negotiate the best way to speak to and get along with strangers.

Perhaps I became a theater director partially due to my inbred need and compulsion to know exactly where I am and to control things. Generally, I am the one who chooses the project, I prepare for rehearsals and I establish the rules and the circumstances of the rehearsal hall. I largely determine the politics in the room, encouraging a respectful social ambiance. Ultimately, I am the decider-er. And yet the concomitant requirement for the craft of directing, for the artistic process, and for creating the circumstances in which resonance can occur, is to work with what I have and allow for the unforeseen, for happenstance, for things that cannot be explained and for associative flights of fancy. Despite my longing for security and decisiveness, I must be willing and able to get lost in the process, to welcome the release of control over orientation and stability, to be open to the possibility of change while at the same time making strong and committed directorial choices. This sublimation of will in service of receptivity requires the willingness to get lost and is a crucial ingredient in the creative process and in the cultivation of resonance.

3

Sensation and Perception

Audience Experience

> someone sees a play. they ask, what's it about? i'm, like, you just saw it. it's "about" the experience you just had. . . . blank face. . . . but what's it about? they ask again. . . . hmm. maybe it's time we chat about how the play is the thing & not a stand-in for some other thing—
>
> Twitter message posted by playwright
> CARIDAD SVICH

A play is not only about understanding its narrative or thematic meanings, but, as suggested in the Twitter post above, is also about the experience you have just had. But what *is* the experience you just had and what makes it resonant? And how does attending the theater differ from other life experiences? An audience in the theater experiences a play on different physiological planes, which resonate in separate regions of human perception. Psychologists differentiate three distinct localities or frequencies: the cognitive, the somatic, and the affective. Even though these three areas can be considerably entangled, an examination of each one separately can be useful in considering what it means to be an audience member at a performance.

Cognitive Experience

After seeing a production of Sophocles' *Oedipus Rex*, if I am asked to describe the play, I would probably say that it is about a man who kills his father, sleeps with his mother, and the land of Thebes is thrown into chaos. This is what the cognitive part of my experience tells me. The cognitive engagement with theater is the mental action or process of using thought, attention, and the senses to create meaning. Cognitive processes use existing knowledge to generate new concepts. When we watch a play, we see and hear the characters on the stage, and at the same time we imagine what they may be thinking. We are cognitive participants in the action.

The word cognition comes from the Latin verb *cognosco* (*con* "with," and *gnosco* "know"). Cognition means to recognize and conceptualize. Cognitive empathy is the ability to put yourself into someone else's shoes and attempt to look at what is happening from their perspective. We tend to assume that the cognitive experience of a play is its main attraction but, in fact, there is so much more going on. The experience of the production is far richer than an intellectual interpretation of the play and success can be measured by its ability to deliver a feast of affects, sensations, and resonances. The cognitive experience is only one of several levels of frequencies that clamor for dominance and my description of the story of *Oedipus Rex* leaves out a variety of human resonances happening in other areas of affect.

Somatic Experience

You really have to be emotionally and physically involved, otherwise you become superficial and you just sit in your own little world and read the news.

AI WEIWEI

The somatic experience of a play is the sensual and aesthetic involvement of the body and the nervous system, activated by

the stimuli and the circumstances of the production. The word *soma* in ancient Greek is "the body" and somatic comes from *somatikos*, which means "of the body." The somatic experience, as distinguished from that of the mind, refers to the sensations and perceptions of the body. It is through the felt bodily experience of being and existing, that we come to understand our interactions with the environment in a visceral way.

Musicality is part of the somatic experience of theater, triggered not only by the actual music played, but also by the rhythms, the harmonic range of actors speaking, their movement, the shifting lighting, and the sound design. An actor's voice can be felt viscerally in the bodies of the audience and an actor's breathing can modify an audiences' own breathing. Recent research confirms that while watching live theater, the heartbeats of an audience synchronize, regardless of whether or not the individuals know one another. To tangibly sense and physically adjust to another person's experience is called somatic empathy. Watching a familiar action, performed with specificity, triggers the body's mirror neurons, which are cells that activate both when we perform an action and also when we see a similar action being performed or hear it being described. Even non-narrative performance can trigger somatic empathy. Being in the audience for Elizabeth Streb's *extreme action* performances can also trigger somatic empathy. Watching her dancers crash through glass and leap off of high places can cause physical sensations of delight or fear, all variegated flavors of somatic empathy.

Throughout history, both in the United States and all over the world, the theater has and does often encounter resistance from religious organizations, and it was often outlawed within puritan and fundamentalist cultures. In the eighteenth century, laws forbidding the performance of plays were passed in Massachusetts, Pennsylvania, and Rhode Island and, during the American Revolutionary War, at the urging of the Continental Congress, plays were banned in most states. In 1794, the president of Yale College, in his "Essay on the Stage," declared that "to indulge a taste for playgoing means nothing

more or less than the loss of the most valuable treasure: the immortal soul." In spite of such laws, the theater has managed to rise up again and again. Is the puritanical and fundamentalist fear of theater due to the blatant involvement of the senses? Is the theater too juicy, too corporeal, and over-stimulating? Did the actors' stimulation of the audience's imagination trigger too much carnal action on the somatic level?

The somatic is the embodied experience of being and it is central to our survival and to the quality of our existence. For theater to be resonant, it is essential that knowing and learning happen on the somatic as well as on the cognitive and affective level. Successful acting uses every aspect of the body including the voice, posture, stride, gaze, muscles, face, and hands, to build a symphony of affect and cognition. Directors, too, employ a nonverbal somatic repertoire including timing, staging, and musicality to weave a rich tapestry of physical sensations throughout the production.

> I've learned that people will forget what you said, people will forget what you did, but people will never forget how you made them feel.
>
> MAYA ANGELOU

Affective Experience

The word *affect* can be interchangeable with the word *emotion*. The affective experience of a play refers to the *emotions* that are triggered by the event of the production. In the theater, an affect is what acts upon and emotionally influences the audience. Affects are generally nonlinguistic forces that are neither under conscious control nor necessarily within one's awareness, and they can only sometimes be captured in language.

The political arena is largely led by affect. The currency that connects our bodies and fuses us into communities is not a

rationally elected choice, but rather a felt urge. Both during and after the 2020 Presidential Election campaigns, pro-Donald Trump rallies have been largely affective rage-fests capitalizing on fear and hatred, the desire for a perceived macho-strength and the distancing of shame. In contrast, a pro-Bernie Sanders rally was also largely affective with its soaring optimism and calls for a more just society.

Emotion and Affect

A theater performance is a collaborative venture between performer and audience and, at least in my own experience, it cannot exist without the actor who performs and the spectator who responds. To attend the theater is to risk the agony, the pleasure, and sometimes the culpability of being a witness, in an infectious co-existence with other audience members. In the rapture of live performance and with the contagion of laughter or of shame, actors and audiences negotiate this dynamic contract together.

Actors know that acting is so much more than memorizing words on a page. They agree to be vulnerable onstage, to expose their bodies in physical acts such as crying, aggression or intimacy; acts that they might not otherwise perform offstage. Actors display themselves both literally and metaphorically, and audiences, in turn, agree to watch, to witness the actors' vulnerability and potential mortification. To be an audience member is to accept this indignity, to agree to risk being mortified for the performers if something goes wrong, and to risk sharing intimacy and vulnerability with them if things go right. Actors and audiences accept these risks together in the mutual entanglement and second-to-second negotiation of theatricality.

In a 2006 TED talk, life-strategist Tony Robbins strode onto the stage to discourse upon the hidden forces that motivate human action. Many luminaries were present in the audience, including the former Vice President Al Gore. Robbins

covered many topics in his eighteen allotted minutes and at one point he asked the esteemed assembly what reasons they would offer for the failure of any of their endeavors. "What gets in the way of successful action?" he asked. Someone responded, "I did not have the time." Another said, "I did not have the money." Another, "I did not have the technology." Suddenly Al Gore, sitting in the front row, shouted out, "I did not have the Supreme Court!" Robbins, with both humor and warmth, briefly acknowledged this comment and then turned away to continue his 18-minute talk about how resources are rarely the real obstacle. Suddenly he stopped and turned back to Gore. "The Supreme Court was not the defining factor," he said. "If you had communicated human emotion, something that I experienced with you the day before yesterday on a level that is profound as I have ever experienced, with that emotion, I believe that you would have beat his ass and won." In saying these words, Robbins was pointing at Al Gore's evident passion and emotion for his environmental initiatives. But while running for president and during the presidential debates, Gore did not communicate sufficient emotion or passion for his policies. For this, he lost his audience and he lost the election.

Emotion and affect are the great motivators that ultimately define what we become. Emotion is the force of life and it drives us. Emotion can seal memory and it can change the wiring of the brain. Emotion and affect lie at the heart of the theater experience.

Conscious and Unconscious Actions

Action is the essential grammar of the theater. In his book *The Necessity of Theater*, the philosopher Paul Woodruff defines the theater as "the art by which human beings make human action worth watching in a measured time and space." An action is what an actor, playing a character does in order to achieve an objective. An action worth watching requires the

actor to undergo an intensive process of concentration and editing. The collaboration between the actor in performance and the audience as witness and their shared attentiveness to the action, can lead to resonance.

My colleague, the remarkable actress Ellen Lauren, who has played the roles of Agave with Tadashi Suzuki and Dionysus with SITI Company in Euripides' *Bacchae*, can demonstrate what an actor must do to make actions worth watching. What is required is acute consciousness. But the road to conscious-action-worth-watching is tricky, often elusive, and requires a dedication to practice and experimentation.

I watched Ellen teach a class that she calls "speaking." At one point, she asked an actress to move slowly from a crouched position on the floor to standing. As the actress began to rise up, I could see that some of her moves were automatic, unconscious and, consequently, appeared blurry to an audience, while others, in contrast, were intentional, tangible, and hyper-visible. Ellen was able to bring the actress's attention to the unconscious, unintentional movements by asking her the following question: "How will an audience perceive your actions?" In this exercise Ellen was introducing two fundamental skills required for acting and speaking: consciousness and differentiation. Watching the actress move from crouching to standing, I could clearly see the difference between conscious and unconscious action and her success or failure to differentiate one moment from the next. Under the pressure of Ellen's laser eyes and with the actress's attention now acutely focused upon every single movement of her head, weight shift, or stop, each move became visible and distinct to those of us watching.

The ability to stimulate consciousness and to differentiate one moment from the next is what distinguishes skillful acting from mediocre acting. But to bring acute attention to one's every move requires a dedication to training and to the practice of acting for the benefit of an audience's experience. Consciousness arises from an awareness of the senses; the perceptions interacting with the surrounding world. Perception is the initial component of action, but it is also an action in

itself. To perceive is not merely to experience sensations or to receive sensory impressions, rather, it is to recognize those sensations. No conscious action can happen without awareness and recognition. But then, the *differences* between these perceptions are also crucial. Differentiation is the actor's capacity to distinguish one moment, one action, from the next, and to allow each one to be unique. Rather than blending together movement and speaking, a successful actor marks the separateness, the particularity, and the difference between the milliseconds of time passing. In order to render these moments visible and tangible to the audience, the actor brings consciousness and intention to each and every instant and to each single action, punctuating movement with artful stillness.

To understand consciousness—the fact that we think and feel and that a world shows up for us—we need to look at a larger system of which the brain is only one element. The brain does not achieve consciousness on its own, but rather it arises from an organism's interactions with the surroundings. Consciousness is an achievement of the whole body within its environmental context and it requires the joint operation of brain, body, and world.

Perception is not passive, but rather, it is located simultaneously in thought and action. Thought arises from the entire physical being when it is dynamically and intentionally involved with the environment. According to cognitive science, we sense first, then we represent, then we think and plan, and last of all, we move. But this all happens in quick succession. We not only take in the world, but also, we bring the world into existence, and part of that creative act is to recognize one's immediate surroundings. Intention matters. The distinction between something happening *to* us or us consciously acting, is intention. For an actor to bring the necessary intention to perception and representation, there must be a deep commitment, a dedication, to staying present, to remaining acutely aware of the separate moments of being that are, in turn, shared with someone else who is watching and listening.

Avoid. Approach. Attach

Action is the process of doing something, usually to achieve an aim. Neuropsychologist Rick Hanson proposed that all human actions fall under three fundamental motivational categories: Avoiding, Approaching, and Attaching. Each action was developed during the gradual evolution of the human brain. The reptilian brainstem cultivated the ability to *avoid*, thereby enabling us to escape harm. The mammalian limbic system widened the capacity to *approach*, reinforcing the potential rewards of drawing close, rather than avoiding. The primate's frontal cortex augmented the development of the human brain with the capacity to *attach*, thereby creating a sense of "us" as opposed to "me."

In our daily lives, we tend to shift between these three actions in symphonic form: avoiding, approaching, and attaching. In the constant enactment and re-enactment of these actions we have a choice; in any particular moment we can either act *reactively* or *responsively*. Reaction can make the avoiding fearful and make the approaching violent and make the attaching desperate. Responsive action, on the other hand, can bring artfulness and ease to our engagements. When we respond rather than react, we take the situation in and decide the best course of action based upon values such as reason, compassion, cooperation or ethical considerations. Responding requires intentionality and tends to be more conscious. In the context of the theater, an actor cultivates restraint in order to make avoiding, approaching, and attaching both conscious and worth watching.

Objectivity and Subjectivity

If people want to see something they already understand, they shouldn't go to the theater. They should go to the bathroom.

BERTOLT BRECHT

During the late 1990s, I co-taught a class with the multi-talented voice guru Kristin Linklater for MFA directors and actors in the Shapiro Theater at Columbia University. One afternoon, I told Kristin that I would have to leave class a few minutes before the scheduled 5:00 p.m. conclusion in order to catch a Metro North train. We agreed that she would lead the final hour and that I would participate in the class until my departure. During that final hour, Kristin taped large pieces of construction paper of different colors at regular intervals around the walls of the large black box theater. At first, she asked us to look around and to choose the color that appealed to us most. Then she told us to approach the sheet of colored paper. I chose dark blue. As I stood in front of the large piece of blue paper, I began to feel the color having its effect upon me. As I stood facing it, the color transformed from information into sensation and then from sensation into emotion. After a while Kristin asked us all to leave our spot and to choose a new color. Although I was reluctant to move away from the gorgeous blue, I followed her instructions and found a rectangle of forest green. Oh, green! What an electric experience. How vivid and different the encounter with green was from the feeling of blue. After a few minutes of green, Kristin asked us to choose yet another color. OK, so I left my green and walked towards another radically different experience: Yellow! Yellow! Yellow! What a shock. Yellow! Yellow replaced green! The contrast between colors felt pronounced and even intense. Then again, we had to move on to yet another color where I encountered red, the redness of red. Red! Yes. And then the next color and then the next all assaulted my senses. As I moved from one to another, each color transformed into a physical sensation of difference. Kristin asked us to speed up and after a while, together with the students, I was running from one rectangle of color to the next. The explosive and diverse impact of changing colors, faster and faster, hit me with increasing power—Crimson! Electric Blue! Pink! Purple! Orange! Green! Violet! Yellow! Suddenly, amidst the riotous assault of color, I glanced at my watch and realized that, if I

did not leave immediately, I would be late for my train. I grabbed my bag and coat, fled the theater onto Broadway, jumped into a cab that took me to the Metro North Station on 125th Street and ran up the steep stairway onto the train platform just as my train entered the station. I boarded the train, sat down, and suddenly realized how little I had been experiencing color, sensation, and joy in my daily life. I burst into tears.

Every day our bodies and minds undergo a play between two distinct states: objective and subjective. Philosophers distinguish between the *epistemological*, or knowledge-based reality, and the *ontological*, the experience of existing. In most waking moments, we receive vast amounts of information from which we make predictions. Sometimes the circumstances line up properly and through our own acute attention we can become conscious of the experience of experiencing. But mostly we career unconsciously back and forth between the two different states of being, objectivity and subjectivity.

I burst into tears on the Metro North train that day realizing how little I had been *experiencing* color, sensation, and joy in my daily life. An accumulation of the recent loss of both my parents combined with a problematic love relationship had put a damper on my experience of the differing qualities of sensations that can be felt from one moment to the next. Perhaps to protect myself from the pain of experience, I had allowed my life to become dominated by the epistemological rather than the ontological, the objective rather than the subjective. I had lost the creative balance between the two possible states of being. Sitting on the train, traveling north, I felt how my existence was degraded when it lacked regular exposure to the wide range of aesthetic experiences that are available in every moment. This insight helped me to begin to re-establish a balance between the two states of being.

The word aesthetic is derived from the Greek, *aisthetikos*, meaning "sensation." The opposite of aesthetic is anesthetic. In medicine, anesthetics are generally administered during surgery to take away sensation. Art, on the other hand, can restore

sensation, via the administration of aesthetics, to experience. Viktor Shklovsky, the Russian formalist theorist of the early part of the twentieth century, wrote: "The function of art is to impart the sensation of things as they are perceived and not as they are known."

My encounter with the colored papers on a black wall of the Shapiro Theater and the subsequent emotions that flooded my body reminded me to attend to the balance between objectivity and the more immediate, visceral, and differentiated physical sensations of each moment. Through evolution and natural selection, all living beings developed into effective prediction machines using sensation and perception to negotiate the world. As humans, how we juggle these perceptual tools—subjectivity and objectivity, epistemological and ontological—matters. One mode of perception can help to balance the experience of the other. Analysis can support sensation and sensation can, in turn, help in the successful navigation of the world.

The philosopher Martin Buber proposed a two-fold mode of our relationship with the world, distinguishing between the "I-It" and the "I-Thou" approach. He called the "I-It" mode, *experience*, and the "I-Thou" mode, *encounter*. "I-It" objectifies the surrounding world. We categorize one another, creating distance between us. Buber suggested that in a predominantly "I-It" society, humans feel alienated because of the emptiness brought upon by their lack of relation with the world. Entering into "I-It," one makes the *other*, whether another person, a tree, a cat, a piece of colored paper, an "it," a mental representation, separate, created, and sustained by the individual mind. With "I-It," I am an objective observer collecting data, analyzing it, and making theories about it. The necessary distance between the "I" that experiences and the "It" that is objectified is heightened. One is subject and the other is object.

The "I-Thou" relationship, on the other hand, is truly interactive with the world. With "I-Thou," the object is encountered in its entirety, not as a sum of its qualities. To approach the other—another person, a tree, a cat, a piece of

colored paper—in the "I-Thou" mode, I meet the other without any qualification or objectification. I enter into an affiliation with the object, I participate in something with that object and I am transformed by the encounter. Buber wrote, "'I-It' can never communicate with our whole being while 'I-Thou' can *only* exist when communicating with our whole being." Perhaps, suggested Buber, this "I-Thou" encounter is best described as love.

Not-self

When I confront a human being as my Thou and speak the basic word I-Thou to him, then he is no thing among things nor does he consist of things. He is no longer He or She, a dot in the world grid of space and time, nor a condition to be experienced and described, a loose bundle of named qualities. Neighborless and seamless, he is Thou and fills the firmament. Not as if there were nothing but he; but everything else lives in his light.

MARTIN BUBER

I mistrust the idea of my own separateness or exceptionalism as a person or as a personality in the world. I do not feel that I am a singular being, detached from the world that I inhabit; rather I suspect that every fiber of my being is linked to my friends, to my loves, to the environment, to my ancestors, and to everything that I come into contact with. The Buddhist concept of *Skandha*, or the five aspects of an individual being's experience of the world, suggests that we are made up of five factors, or phenomena, that constitute and explain a sentient being's experience of living. Each of these five factors has its own integrity and composition: 1. Form (body); 2. Feeling (sensations that arise from the body); 3. Perceptions (intake through the senses); 4. Mental activity (concepts and thoughts); and 5. Consciousness (awareness of all five aspects). These five aspects work in concert to evoke the sensations and perceptions of being a person or a personality. According to the teaching,

through studying the five *Skandhas*, one can attain the wisdom of *not-self*.

Art Brain

The purpose of art is to impart the sensation of things as they are perceived and not as they are known. The technique of art is to make objects "unfamiliar," to make forms difficult, to increase the difficulty and length of perception because the process of perception is an aesthetic end in itself and must be prolonged. Art is a way of experiencing the artfulness of an object; the object is not important.

VIKTOR SHKLOVSKY

Upon entering the vast Turbine Hall at the Tate Modern in London recently, one of the first things that my wife, Rena, and I noticed was an old truck on the bridge inside the Turbine Hall. "Is that a real truck, or is it art?" I asked. Because of its odd placement, I consciously switched on my art brain and decided to look at it through the lens of art. As I approached the truck, I learned that it was a political piece by the artist Ernesto Salmeron who had transported a military truck from Nicaragua as a stimulus to interrogate the political functions of public spaces. But I was also aware of the conscious switch in brain function that I had made in how I was engaging with the truck.

When I enter a museum, I tend to shift unconsciously to my art brain. I prepare myself to experience the exhibition with a special lens, with my aesthetic sensibilities dilated. There are many wonderful examples of visitors to museums who mistake a mop and bucket left out by a maintenance worker for an art installation. How perfect! How instructive. How useful. In a reverse instance, would a viewer respond the same way to a masterpiece normally enshrined in the Metropolitan Museum of Art if they beheld the same work displaced, say, at a garage sale?

What makes something art? What is the difference between artistic expression and sketching a map onto a scrap of paper to help someone navigate back home or dancing to music on the radio? The philosopher Alva Noë's book *Strange Tools—Art and Human Nature* considers these questions directly. For Noë, art is rooted in life and at the same time it is a reflective and epistemic practice in its own right. The "strange tools" of Noë's title address how works of art engage the very inherited systems that allow us to move through life, including talking, moving, perceiving, signaling, dancing, writing, etc., and at the same time strip them of their ordinary functions so that they can be perceived anew. What artists do is an investigative research, a philosophical practice and what they create is a meditation on and disruption of the very systems that organize our lives. Art requires us to ask: "What is this? What is this for?", thus revealing something about ourselves and our habits and traditions.

In life we talk together, we dance, we write, we draw pictures. All these activities are shared and culturally shaped. Art, according to Noë, begins when we consider the nature of these pursuits. And so, choreography is not only personally motivated expression, it also simultaneously reflects upon the nature of dancing and does nothing less than reveal the impulses that make us dance. We dance naturally in our daily lives, but dance does not become art until it undergoes a process of reflection, investigation, and rearrangement. In a similar sense, visual art celebrates the human propensity to draw, where pictures become an instrument for seeing. Literature and poetry conceptualize and reflect upon the act of writing and storytelling. Art is not simply something to look at or to listen to, rather it is a challenge, a dare to make sense of what it is all about. Art aims not for satisfaction but for confrontation, intervention, and subversion.

To switch on the art brain, I engage with the world in very particular way; I step back and move closer at the same time, heightening the senses and the perceptions, open to surprise and the pulse and variations of patterns. The art brain requires

heat and coolness simultaneously. Engaging the art brain invigorates the act of perception as well as the act of creation. I know that what I bring to a piece of art is as important as what the art gives to me. Oscar Wilde suggested that one approach a work of art with a "temperament of receptivity."

Receptivity

I am well aware of the necessity to approach the rehearsal hall with a temperament of receptivity. But I also know that preparing for a rehearsal requires a different use of the brain. In this phase, I try to access my cognitive, planning brain, which gives me the ability to forecast, to analyze, and to access logic. This is also true for the time after a rehearsal when I recollect what happened and when I want to formulate new plans for the next rehearsal. But within the context of the rehearsal, I bring a different attitude and a more intimate way of interacting with what is happening; I must be able to resonate with the actors and allow "things" to speak to me on their own.

How does the brain respond to art from a biological and evolutionary standpoint? What are the neural mechanisms behind the creation and appreciation of art? What is going on in the art brain? Neuroaesthetics, an innovative new field of research that investigates the possibilities of applying the science of the brain to the study of art, is swiftly gaining momentum in both the artistic and scientific communities. According to neuroaesthetics, activating the art brain arouses an extremely complex whole-brain response that brings many usually disparate aspects of mind into play simultaneously. The blood flow increases in the brain and I consequently feel connected to something larger, wider, and more expansive. This may explain why the feelings engendered by art are so difficult to articulate and yet so profound.

Each distinct art form activates different combinations of areas in the brain. According to neuroaesthetics, the delicate sadness evoked by masks worn in the Japanese Noh theater

engages the right amygdala of the brain. When people feel "moved" by art, it seems that two systems in the brain that are normally separate are activated simultaneously. When the focus is directed at the art, the default mode network which is normally associated with "mind wandering" is also activated. Perhaps this is what creates the sense of distance and intimacy at the same time. By being aware of these different brain functions, it may be possible to become a more effective artist and offer audiences artistically richer, more resonant journeys.

Lose your mind in order to come your senses.

FRITZ PERLS

At the age of seventeen, I lived for a few summer months in a commune in Newport, Rhode Island. A beautiful blond boy, one of the inhabitants of the house, started to act oddly at all times of the day and night. He had ingested prodigious amounts of LSD and mescaline over a relatively short period of time and had lost all connection to reality. One morning I walked into the sunlit kitchen of the house to find him laughing hysterically while repeatedly slamming a shoulder-high cupboard door shut. Playfully, he pushed the door closed and then it would bounce back at him again. More laughter. He pushed it again and it bounced back again. The repetition of the door bouncing back and forth seemed to thoroughly delight him. Apparently, he had not taken hallucinogens that morning, but the accumulation of drugs over time had simply tipped him into a zone in which the universe was animated in a way that endlessly pleased and entertained him. He had accessed the zone of the art brain, albeit artificially, and, to him, the world was wildly alive.

I have also been around a few people undergoing schizophrenic breakdowns and can attest to the fact that a psychotic breakdown and the journey to recovery can be long and arduous. Nevertheless, there can be moments, similar to a drug-induced delirium, when the world feels alive and everything seems to emit special meanings. "That tree is pointing at me," cried a dear friend in Northampton,

Massachusetts, as I tried to get her to cross the lawn to the safety of her own doorway. She also expressed fear that others could hear her thoughts and felt that messages that radiated colors were sent in the wind.

Neither drugs nor schizophrenia are ideal ways to access the inherent aliveness of the universe. And yet, artists must work with a similar receptivity and an aesthetic sensibility and perception that allows the world to speak directly to them. But in their daily lives, outside of their studios, artists cannot afford to be overwhelmed by the innate overabundance of impressions and marvels of their surroundings. In the artistic process, the art brain delights in cupboard doors bouncing open. Trees point. A sock in the corner of the rehearsal hall emits meaning in relation to the other objects in the room. And yet, like a medical doctor leaving a hospital, the artist also must be able to leave the rehearsal hall and go back out into the world without being overwhelmed by the plethora of overly meaningful sensations and perceptions.

To approach the world with receptivity, with the art brain turned on, requires encounters without the ingredient of desire. In our current hyper-capitalist consumerist culture, advertising encourages us repeatedly to want what it is that we see. Vision has become the dominant sense. When I walk down the streets while hungry, I only see bakeries. And in the process of wanting, we can too easily become desensitized to suffering, injustice or ugliness. Therefore, we must be diligent about renewing our capacity to perceive with acuity. In art, a temperament of receptivity requires one to interact with the environment without the added ingredient of desire. As Joseph Campbell suggested, we do not desire to eat Cezanne's apples, rather we are stopped by the apple-ness of the apples in the painting.

The Act of Seeing

Perhaps we could say that the power of theatre is that it gives us the opportunity of a sustained gaze where we can move slowly from looking to seeing. In such moments of

ocular transmutation, we catch a glimpse of something other, something deeper; a second reality that tells us more about ourselves and the world we inhabit. This is the gift of theatre, allowing us to see through things to their core, where things are brought to light that might otherwise remain hidden.

BRIAN KULICK

The word theater is derived from the ancient Greek *theatron*. *Thea* means eyes and *tron* is a place. The theater is, literally, a place of seeing. In ancient Greek *theoros* was the word for spectator, or, "one who observes the vision" and so the act of being a spectator included both witnessing and participation. In the ancient conception of *theoros* the spectator was considered to be an envoy sent to consult an oracle and bring back the news. The word *theoros* is close to the Greek word for theory, *theoria*, and derives from the Greek *theorein*, which means to look at, to contemplate, to speculate. This may explain why the word *theory*, in English, suggests not quite resembling something real. *Theorein* combines *theion* (the divine) and *orao* (I see), i.e., "I contemplate the divine."

At first, I understood the ancient Greek notion of theater as "a place of seeing," and that the theater was where an audience goes to in order to see. Then, after reading Declan Donnellan's superb book *The Actor and Target*, I realized that, in fact, the theater is the place where the audience goes to see the *actors* see; the audience becomes a witness to the act of an actor seeing. And then, in turn, the actors must allow themselves to be seen. What remains true to this day is that the social dimension of theater is the contact between the audience and the performer. It is the communication that is happening and the reciprocal dependence between art and spectator, intertwining both viewer and viewed. The theater does not exist without the audience, who participates in bringing the event into existence. Theory and spectator are fused.

In Euripides' *Bacchae*, Pentheus arrives onstage, half-maddened by the god Dionysus; his vision is blurred, and he

sees double. Pentheus glimpses two suns while Dionysus seems to him to be a bull. The audience watches Pentheus *see*. The drama unfolds for an audience through what the actor-character is perceiving. In the theater it is not always necessary to build complex scenery or detailed props because the joined power of what the actor-character envisions, and the audience's imagination, constructs castles and landscapes and can turn a paper bag into a looming mountain. Theater at its best, is capable of making the invisible visible.

The Art of Seeing

To learn to see—to accustom the eye to calmness, to patience, and to allow things to come up to it; to defer judgement, and to acquire the habit of approaching and grasping an individual case from all sides. This is the first preparatory schooling of intellectuality. One must not respond immediately to a stimulus; one must acquire a command of the obstructing and isolating instincts.

FRIEDRICH NIETZSCHE

As a theater director, my job is to watch over, to pay attention, to bring empathy, and quick thinking to each rehearsal; to be ready to laugh or to be amazed or even disappointed. In rehearsal, I try not to react. Rather, I aim to be ready to respond. I must not only be patient and wait like a fly fisherman, sensitive to the slightest tug, but also, at every millisecond, to be ready to change course. I face the stage with hyper-presence and look without desire. I wait. I wait for looking to become seeing.

Most of daily life involves a lot of looking, but not much seeing. Looking is a physical action, defined as turning one's eyes toward an object. Generally, I look in order not to bump into things. If you see me turn to look at a bicycle passing by, you can tell what I am doing based upon my action. Seeing, on the other hand, is not necessarily visible to someone watching.

Seeing requires perception on the part of the person who is looking.

The art of seeing has to be learned.

MARGUERITE DURAS

As a society, we have come to value looking over seeing and we are becoming intolerant to ambiguity. Looking, unlike seeing, especially in a capitalist society, is linked to desire and acquisition. We are primed to desire and enticed to feed upon what we are looking at.

Much of our current technology is engineered to increase our passion to consume. In recent years, social media and internet shopping have transformed us into looking machines. The consumer culture is filled with desirous cravings—for the latest news, for the newest gadgets, or for the most appealing selfie. Perhaps we are so inundated with visual input that we simply cannot take the time to attend to it all or discriminate one thing from another or even to edit. We scan, we scroll, we change channels or websites, in a desperate search for novelty. The activity is hypnotic, and it is addictive. We search less for meaning and more for the thrill of novelty and look with increasing desperation, moving from one image to the next to the next and to the next.

These incessant urges have become a nearly inescapable part of our contemporary lives. The imagery fascinates, motivates, and delights but ultimately it can never be enough because the novelty of it all is so enticing that we are not given the opportunity to go into depth with anything.

The uninterrupted connection provided by the internet is both highly beneficial to our lives but also hazardous. Because our engagement in the present moment is constantly interrupted, sustained connection and deliberate slowness are increasingly rare. Deliberate slowness, or the experiencing of moments of being in an altered time signature, allow us to register multiple layers of time, history, and motion. Patience and the deliberate engagement of delay can intensify our temporal and spatial

experiences and become a powerful artistic tool in the journey towards resonant art.

The tree which moves some people to tears of joy is in the eyes of others only a green thing that stands in the way.

WILLIAM BLAKE

Seeing, on the other hand, implies a stronger commitment than looking and requires the attempt to understand the complexities and ambiguities of what is being looked at. Seeing transcends desire and involves far more than visual engagement. In order to see, I must not only look, but also I must pay attention to what I am looking at. Seeing engages all of the senses, receiving and interconnecting them, while weaving together memory and an awareness of context. In order to turn looking into seeing, I must linger, I must interest myself in the details that are always finer and more nuanced. If I have the patience, I can begin the process of seeing what a thing is about, what it is made up of and perhaps even how it relates to other things in its environment. The object of contemplation enters the heart and mind directly and eventually the ambiguities dissolve. And I find that I can live with multiple meanings and thrive in ambiguity. The boundaries between the self and the world are transcended, and I momentarily merge with the things seen.

There are always flowers for those who want to see them.

HENRI MATISSE

In my own daily life, I have come to realize that, actually, I do not see very much. I am always looking, but I rarely see. I am impatient and have the tendency to look around swiftly with minimal attention. I have a hyperactive mind that is always planning but rarely settling or noticing. Fortunately, this changes when I am in a rehearsal or in a theater or in a classroom. I am grateful that I am able to see, at least some of the time.

Habit

If two roads open up before you, always take the most difficult one. Because you know you can travel the easy one.

RAYMOND BELLE

As we grow older, our experience of the world has a tendency to become muddled by habit and the assumptions of routine. Children see naturally because they have not already learned about how they are supposed to categorize what they are looking at. They puzzle through, notice, and work out each detail with a freshness that radiates both spontaneity and play. As we grow older, many of us lose our ability to see and we begin to accept the assumptions that have accumulated while looking. By the time we reach adulthood, most of us have learned to operate through such deeply engrained patterns of language and behavior that virtually all of our communication involves projection, assumption, and bias.

But lazy and received habits can be broken and renewed ways of seeing can be cultivated. To see the world anew, we must make a concerted effort to refresh the act of seeing. I studied the Japanese martial art Aikido with a teacher who, after many years of practice, decided to take up drawing classes so that she could see the moves of her Japanese Sensei, or teacher, with more clarity. She had reached what she felt was a saturation point where she could see nothing beyond what she had already discovered.

Practice with Intent

In his book *Outliers*, journalist Malcolm Gladwell popularized the now ubiquitous "10,000-hour rule," which he learned from Swedish psychologist Anders Ericsson. Gladwell suggested that in every field of human endeavor, people do not become expert at something until they have put in about 10,000 hours of practice. The notion is enticing, but Gladwell

apparently misunderstood Ericsson's research and left out the most crucial ingredient in the recipe for expertise: One must practice *with intent*.

Ericsson distinguishes between deliberate and generic practice. He proposed that to excel we must engage in "deliberate practice," which involves constantly pushing oneself beyond one's comfort zone. Deliberate practice is aimed at a very particular goal and usually requires assistance from an expert. And deliberate practice needs dedication. While regular practice may call for mindless repetitions, deliberate practice involves sharp focus and an enthusiasm for improving performance. It must be purposeful, systematic, and in sync with conscious action.

We humans were designed by evolution for delusion and self-deception. We are also prone to a general fearfulness of anything that is not habitual. Without purposeful, conscious, and dedicated intervention, we are left to drift sleepily from one vague situation to the next, going through the moves but not being fully part of the action. Ultimately what we focus on and how we attend to what we are focusing on is what creates consciousness. Without the rigor or force of consciousness in concert with deliberate practice, we can become endless repetition loops. Intentional habits have a positive influence on actions, which are the conduit between the private inner life and the external world. Actions are the bridge. Actions are an organism's dynamic dance with the environment.

While it is true that habit, doing what we do because we always do it, is the primary enemy of every artist, habit is also, emphatically, necessary to the creative process. In our daily lives, consciously formed habits are valuable and necessary to getting us successfully through each day. As a child I was taught to brush my teeth twice a day. Habit. In adult life I established the habit of regular exercise. Habit. Reading books became a habit that I continue to pursue and enjoy to this day. T'ai Chi Chuan is the daily practice of intentional movement. Learning languages and the skills acquired in directing require regular and conscious, intentional practice that ask me to wake

up from the sludge of what Virginia Woolf calls "the cotton wool of non-being."

Acting for the theater is action and consciousness joined together and on the stage the actor's job is to be wide awake in the midst of what is in daily life habitual, unconscious behavior. The complex density of an actor's onstage presence is shaped by setting up a complicated field of contradictions and attitudes in the body. This complexity originates in the central paradox inherent in the art of acting: to stand firm and committed to an action while simultaneously being ready to adjust and change directions in an instant. Presence arises from an actor who makes strong, visible, and courageous choices while, at the same moment, being receptive to change.

Art of Expressive Play

Just as with the art of looking, as we grow out of childhood we generally forget how to play, how to engage using our fullest and most heightened abilities. We get worse at making expressive art. We become self-conscious. We start to doubt ourselves and we lose our spontaneity and ease of play. We lose the unaffected relationship to the expressive act. We also begin to react to the perceived judgment of others, a development that requires a huge effort to overcome. We become more physically and spiritually sedentary and we often choose the road well-traveled rather than the less predictable one. We become, both literally and figuratively, victims of the architects of our environment. The architecture controls us by telling us to move in a certain way. But we can defy this by choosing our own path rather than that of the architect.

A fairly recent urban sport known as *parkour* celebrates this attitude of expressive play in ways that are comparable to our attempts to create resonance in the theater. *Parkour* is a novel way of moving from point "a" to point "b" using the obstacles in one's path to interact with the environment in ways that challenge the use and meaning of our municipal spaces. The

word *parkour* is derived from the French "*parcours*," or "the way through," and it had its origins in a training program for French Special Forces known as "*Parcours du combatant*," or "path of the warrior." The point of *parkour* is to treat a space that is rich in obstacles as play and adventure rather than as a dangerous environment in which to negotiate with fear and trepidation. Individuals or teams run, jump, leap, climb, swing, vault, and roll over urban obstacles such as walls, ledges, parks, and abandoned structures. There is dramatic beauty in these great feats of physical action.

Parkour requires the player, or *traceur*, to see the immediate environment as a way to express, adapt, and free oneself, rather than as obstacles to overcome and to fear. The *traceur* approaches the environment in a novel way, imagining the potentialities for navigation in movement around, across, through, over, and under its topographies. Chau Belle, a well-known *traceur*, describes *parkour* as a state of mind rather than a set of actions, and proposes that it is about overcoming and adapting to mental and emotional obstacles as well as physical barriers. Another *traceur*, known by the name of Animus, describes *parkour* as "a means of reclaiming what it means to be a human being. It teaches us to move using the natural methods that we should have learned from infancy. It teaches us to touch the world and interact with it, instead of being sheltered by it."

The originators of *parkour* created a new urban sport that celebrates the art of uninterrupted connection to the present moment. *Parkour* also throws light upon the assumptions that we make about our immediate environment and our given circumstances. Do we allow a city to trap us or to liberate us? Do our own limitations thwart or energize us? Do the challenges that arise confine us or set us free? Rather than taking the easiest path, perhaps we can consciously choose to embrace and embody the available obstacles that challenge our limits.

To speak, an actor flings herself figuratively from a cliff and carves the experience of speaking mid-flight. She juggles the

experience as it happens. There is no net, no stopping; there is only the arrangement, the moment-by-moment articulation, the uninterrupted connection, and the thrill of lucid expression in mid-air. All of the preparation, all of the rehearsals, only serve to prepare the actor to leap and to juggle in the proximity of a live audience in the present moment. And the following moment. And the next.

Every time we embark upon a new project, we consciously or unconsciously set the bar at a certain height. The scope of the challenges, and our capacity to find adventure in handling them, determine the energy contained in what we produce. For his film *Victoria*, director Sebastian Schipper chose to shoot the entire film in one take. Shot across twenty-two locations in a single 134-minute take, the story follows a Spanish nightclubber who finds herself spontaneously caught up in a bank robbery during one wild Berlin night. Schipper is, in my eyes, choosing *parkour*. He calls his own creativity "a little wild monkey that wants to climb."

An appetite for and the ability to play is as crucial for artists to cultivate as is the development of technique. It is not by chance that playwrights produce something called plays. Play, like *parkour*, is a spontaneous and active process in which thinking, feeling, and doing flourish simultaneously. Creativity is to a large extent enacted in a state that is both committed and playful. When we play, everything is possible, and we are free to be inventive; imagination and free-flow thinking take precedence over routine. In play, the act itself is always in relation to a goal but at the same time the sense of play is more important than the goal.

Both play and acting *in* a play require flexibility, generosity, spatial and temporal intelligence, and the ability to track multiple streams of information simultaneously. Everyone involved must welcome and be ready for fast-paced action, able to make split-second decisions, communicate clearly, and not surrender to anxiety all the while finding ways to turn difficult obstacles and perceived enemies into allies. The *traceur*, or player, needs to gather information and evaluate

options swiftly, formulate and follow a strategic plan, and also know when to deviate from that plan. Play requires an expanded sense of self and a more expansive mode of being in the world than what is called for in daily life.

The philosopher Mircea Eliade proposed that when we have a choice, it is better to take the harder road. He wrote, "The road is arduous, fraught with perils, because it is, in fact, a rite of the passage from the profane to the sacred, from the ephemeral and illusory to reality and eternity, from death to life, from man to the divinity."

The theater provides a high wire act where actors and audiences alike can adopt a game mindset and maneuver together across treacherous landscapes. The conflict of insurmountable heights in real life can become a playground in the theater. There are real dangers in the theater because in actuality an audience cannot know what will happen. Unlike in literature, visual art or film where the artifact is already made, the theater offers the thrill of a tightrope act in the present moment, where the potential for failure is real, but the flight can be extraordinary. We must simply look around and access our capacity to think like a child.

4

Powerful Triads

Several years ago, the members of SITI Company decided to shift from a single artistic leader to shared leadership model. I changed from being Artistic Director to Co-Artistic Director, joining ranks with Ellen Lauren and Leon Ingulsrud. This three-part structure has been a godsend to the entire SITI enterprise. To make decisions as a threesome adds exponential thoroughness and a depth-of-discourse to each decision. We must listen closely to one another. By understanding one another's different points of entry, we are able to benefit from and incorporate our diverse positions. Each of us looks at the same issue through three separate windows. Leon is highly philosophical in his considerations. Not to say that he is not practical, but he tends towards useful philosophical reflections. Ellen's observations are decidedly practical and action-oriented. Not to say that she is not philosophical or thoughtful about the future, but her sense of pragmatism and her concern for the well-being for each member of the company is crucial. I tend to be project-oriented: where are we headed and what plays and what study will provide meaningful engagement for me, for the ensemble, and for our audiences? I work with the SITI staff to secure commissions and partners from outside the company and to find support for our new endeavors. In this current structure, SITI has benefited from the distinctive geometry of a triad. Rather than flattening into a basic mutual agreement, the odd number three allows for communication, lateral thinking,

argument, and space for a wide spectrum of passions. The convergence of three different points of view within a unified agreement about our overall mission provokes difficult yet positive conversations that can engender decisive action. The balance may be mathematically disturbed, but it is fruitful and hopeful.

Threes

The Triad has a special beauty and fairness beyond all numbers, primarily because it is the very first to make actual the potentiality of the Mondad—oddness, perfection, proportionality, unification, limit.

IAMBLICHUS

Why are threes so powerful? According to Pythagoras, the number three was the first true number. Three is the first number that forms a geometrical figure: a triangle. Three was considered the number of harmony, of wisdom, and of understanding. Three is the number that encompasses time: Past, present, and future. Beginning, middle, and end. Birth, life, and death. We measure our world within the structure of width, length, and height. Three is a sacred number in many religions. Buddhism has the Three Jewels or Treasures; Hinduism has Brahma, Vishnu, and Mahesh, Christianity has the Father, the Son, and the Holy Ghost. Greek mythology has Zeus, Poseidon, and Hades. In Zoroastrianism there are three ethical principles: *Humata* (to think well), *Hukhta* (to speak well), and *Huveshta* (to act well). There are three things that, if offered, a Muslim should accept: cushions, oils (fragrance), and milk. In fairy tales three is a magical number. In literature, heroes and heroines are offered three choices or three tests and then they tend to overcome difficulties on the third try.

Three and Play

The number three is playful, it's inspirational. It's a happy-go-lucky number, very optimistic. It lifts up people around it, doesn't take things too serious. I nickname it the "sunshine number."

HANS DECOZ

The rule of three is common in structuring jokes: two instances of something similar to set up a pattern, followed by a subversive surprise. Counting to three is common in situations where a group of people wish to perform an action in synchrony. "Now, on the count of three, everybody pull!" The rule of three also governs how we talk to one another in daily conversation. According to speechwriter Max Atkinson, studies show that listeners will wait for a speaker to find a third item in a list before taking their turn to speak. But if they go beyond three to a fourth item, the speaker will usually get interrupted. The third item marks a sense of completeness, and we have an ingrained tendency to wait and listen for it.

Beginning, Middle, End

Birth, life, death

Dawn, noon, dusk

"Yes, We Can"—Barack Obama

"Friends, Romans, Countrymen"—Shakespeare

"Government of the people, by the people, for the people"—Abraham Lincoln

"Education, education, education"—Tony Blair

"This is not the end. It is not even the beginning of the end. But it is, perhaps the end of the beginning"—Winston Churchill

"The inalienable right to life, liberty, and the pursuit of
 happiness"—the American Declaration of
 Independence.

"Stop, Look, Listen"

Going once, going twice, SOLD!

Three times is a charm.

Snap. Crackle. Pop.

Hip, hip, hooray

Three strikes and you are out.

Going, going, gone!

Triads and Resonance

The number three can be a useful tool in the path to resonance.
The mind is a pattern-making machine, always looking for
relationships and meaning in the world, always trying to
impose order upon chaos, and to make links between disparate
entities. Three is the smallest number needed to create a
pattern. In Latin, the phrase *omne trium perfectum* means that
everything that comes in threes is perfect, or, every set of three
is complete. Research shows that our brains can comfortably
process up to three chunks of information in our short-term
memory. Above that, brains must work much harder.

In visual art, music, architecture, literature, and theater,
the tension and imbalance that co-exist amidst discordant
components, when lined up accurately within the same
framework, can provide enormous power and enough space to
conjure the conditions for resonance. In considering the
powerful concert of the number three, I must first acknowledge
the power of the number two, also an essential force in the
creation of effective art. Truth and suspense result from the
tension, the opposition, and the disagreement that lie between
two forces. But how is it that properly aligning a virtual trinity,
a three tentpole structure, can also allow space for the necessary
conditions for successful art and perhaps even good governance?

There are many references to triads throughout history including in the writings of Aristotle and Thomas Aquinas.

Ethos. Pathos. Logos

The ancient Greek polymath Aristotle proposed three necessary co-existent modes of persuasion—*ethos*, *pathos*, and *logos*—as a model for effective communication between a speaker and an audience. To be persuasive, these three contrasting modes must function simultaneously and in sync. *Ethos* is an appeal to one's ethics and it starts by convincing someone of the character or credibility of the persuader. *Pathos* is an appeal to the emotions, and it is a way of convincing an audience of the veracity of an argument by provoking an emotional response. *Logos* is an appeal to logic, and it is a way of persuading an audience by reason. These three ingredients, this triad of tentpoles, are the building blocks to persuasive communication and they are highly relevant to the art of resonance in the theater.

Ethos

In considering Aristotle's notion of the speaker's appeal to the audience's ethics, a theater audience needs to be convinced of an actor's integrity. To successfully resonate with the audience, the actor should seem convincingly qualified, trustworthy, credible, and filled with both knowledge and skill. Their vocality, body language, and palpable enthusiasm work in concert with humility, empathy, sensitivity, and concern for the audience.

Pathos

Pathos refers to the actor's emotional effect upon the individuals in the audience. In order to be persuasive, the actor appeals to the audience's feelings by being believable, sensitive, empathetic,

passionate, enthusiastic, likable, encouraging, and credible. The actor must feel a real concern for the audience, building desire and interest and encouraging action and decisiveness.

Logos

Logos is the appeal to an audience's reason. To persuade people requires the relevance and the strength of the message, the content. According to Aristotle, the event must be well structured, clear, understandable, logical, balanced, and memorable. To connect successfully with the audience's *logos* demands that the material can be absorbed and interpreted, that it is provable, convincing, balanced, and unbiased and that the reasoning is memorable and can be easily recalled.

Integritas. Consonantia. Claritas

The influential thirteenth-century philosopher and theologian Thomas Aquinas exerted a considerable influence upon Western thought. His theories about aesthetics and beauty substantially influenced the trajectory of the writer James Joyce. Aquinas proposed three constituent elements of beauty, three criteria for the aesthetic experience: *integritas*, *consonantia*, and *claritas*. This triad of principals, these three elements in concert, these tentpoles, provide the circumstances for an aesthetic experience. The beauty of an artwork is composed of its constituent elements (*integritas*) and is proportional to its ultimate purpose (*consonantia*) and radiates its essential reality (*claritas*).

Integritas means wholeness or completeness. John Cage proposed that if you want to see theater, sit on a park bench, and put a frame around what you are looking at. If you frame what you are looking at with intention, then what is within that frame can be regarded as a single entity, as a whole work of art. This one-ness is *integritas*. Within the frame, nothing

essential is lacking and nothing extraneous is present. An artwork is not a collection but rather it is experienced as one event within a designated frame. Nothing within the field of that frame is dependent upon anything outside of that field. It is whole and complete.

Consonantia means harmony. It is proportionality in relation to an end. Within the frame set aside from the rest of the world is a rhythmic arrangement, a rhythm of beauty, an arrangement. The rhythm or the rhythmic arrangement is the instrument of art and the essence of the aesthetic experience. Joyce stated, "Having first felt that it's one thing you feel now that it is a thing. You apprehend it as a complex, multiple, divisible, separable, made up of its parts, the result of its parts, and their sum, harmonious."

Claritas means radiance or fascination. Due to the concentration of attention by the artist and the audience, the object becomes pure object. *Claritas* engenders aesthetic arrest. The audience is stopped and held. The writer Umberto Eco describes *claritas* as "the fundamental communicability of form, which is made actual in relation to someone's looking at or seeing of the object." *Claritas* radiates intelligibility and it has the power to reveal its ontological reality. Joyce wrote, "When you have apprehended it as one thing and have then analyzed it according to its form and apprehended it as a thing you make the only synthesis, which it is and no other thing. The radiance is the scholastic *quidditas*, the *whatness* of a thing."

> Pick anyone at all—ask them to pick a number from one to four, and they'll pick three.
>
> EDWARD B. BURGER

In previous books, I have written about a few other powerful triads, including Zeami's *Jo. Ha. Kyu* and Jacques Lacan's *The Imaginary. The Symbolic. The Real.* In this very same spirit, here are a few other triads that I have found extremely useful.

Ready. Set. Go!

Ready, set, go is a trope from racing, a shortened version of "On your mark, get set, go!" and it can be a useful triad in creating the conditions for effective action and resonant art. The "mark" of "on your mark" refers to the place where a runner starts, whether a line or a set of starting blocks. "Get set" is a warning that the signal to start running is imminent. "Go" means to start moving. Take off. In the stripped-down version—*ready, set, go*—*ready* means "prepare yourself," *set* means "position yourself," and *go* means "go and don't stop."

Ready

Ready implies everything that brings me to this very moment. Why am I here? What is my purpose? What is my background and what is my training? How am I situated in the world? How have I prepared for this moment? What are the questions that I am addressing? What is my posture and my attitude? How am I positioned for success? *Ready* implies a lifetime of preparation. Recall how heavyweight champion Muhammed Ali or record-breaking sprinter Usain Bolt entered the arena. Both exuded a relaxed demeanor and an eagerness that communicated confidence and energy. Muhammed Ali declared that Madison Square Garden was "too small for me." *Ready* is what I bring with me into the rehearsal hall. *Ready*.

Set

Set requires a specific transition after the *ready* and before the *go*. In track races, the *set* command triggers a shift of the body into the position most optimal to launch a run; a change from one posture, direction or level, to another. Sprinters start in a *ready* crouch position with both hands on the starting line. On the *set* they extend both legs so that the hips are slightly higher than the shoulders so that the majority of the body weight is

between hands and front leg. The energy in this moment before the *go* is full of potential; poised in immobility but also in motion. The outer appearance seems immobile, but the inner is all tension and energy ready to be released.

The *set* is about the focus and the energy needed in order to meet the goals. Short distance runners do not look to the left or to the right. The preparation, the *ready*, has helped them to arrive at the *set*, which is the defining moment. *Set* is about dynamic preparation, composure, impulse and counterimpulse, stillness, and intention. For actors, *set* is the moment preceding an action, whether speaking or moving.

> This is dynamic immobility; the pressure of water on the dike, the hovering of a fly stopped by the windowpane, the delayed fall of the leaning tower which remains standing. Then, similar to the way we stretch a bow before taking aim, man explodes yet again.
>
> ETIENNE DECROUX

The Greek word for energy, *energeia*, means to be ready for action or on the verge of producing work. *Set* happens in stillness, but there is a muscular, nervous, and mental commitment, already directed towards an objective. Eugenio Barba uses the Norwegian word *sats* and suggests that the success of the action depends upon the quality of the *sats*, or, the moment before the action. Jerzy Grotowski called this state "pre-movement." Vsevolod Meyerhold used the word *predigra* or "pre-acting." The mime Etienne Decroux called it "immobile immobility." The *set* can be a stop between actions, and it is filled with potential. My T'ai Chi master Mr. Lee put it succinctly: "To do the not to do," which describes an active-not-doing.

Go

Go is the expression that occurs after all of the preparation; the action is now in service of a goal. *Go* implies movement

and it requires that I put forth the best that lives within me. This is not a moment of hesitation or of thought. I have leapt off the cliff and I am mid-air. I am exerting energy in a focused way. *Go* is intuitive and requires me to give my very best without holding anything back. All of the preparation has led me to this moment, and it helps me to stay present inside this focused effort. An actor onstage, full of air before beginning to speak, feels as though she is leaping off a cliff, shaping the experience on the way down.

Passion. Technique. Content

The producer and critic Robert Brustein introduced me to the idea that in order to make effective theater, three specific ingredients are required: *passion, technique, and content.* He proposed that if one of the three components is missing, the entire enterprise falls apart. This threefold recipe seems to be a particularly powerful example of a tent held up by its supporting principals.

With Brustein's analogy, I am reminded of Borromean rings and of a milking stool. The Borromean symbol is based on symmetrical arrangement of three intersecting circles, the three familiar interlocked rings. Traditionally these are three circles that form an unbreakable unity but if any single ring is removed, the two remaining rings collapse. Similarly, if a milking stool is missing one of its three legs, it is no longer functional. The triad is not effective unless it retains its shape of a triad.

The director/performer Simon McBurney, one of the founders of the UK-based theater company Complicité, conceived of *A Minute Too Late* shortly after the death of his father and following the completion of his training at the Le Coq School in Paris. The piece, one of the Complicité's earliest works, premiered in Edinburgh in 1984 and it toured widely for several years. In 2005, more than twenty years later, I attended a revival of *A Minute Too Late* at the National Theatre in London. I was

astonished at how the production still remained fresh and impactful, drenched in the sense of loss and redolent with the comedy of our often-awkward relationship to death. In his youth, McBurney had clearly lined up all three elements, the same sequence as Brustein's formulation: 1. He is a man with great and sustaining passion. 2. The content of the piece arose from the then-recent death of his father. 3. The Lecoq School had given him palpable and impressive technique. He finished his training and was visibly ready to pounce upon the international theater scene. And his work continues to resonate through time.

Study One. Do One. Teach One

An acting student at Columbia University whose father is a doctor told me that surgeons have a saying: *study one, do one, teach one*. When I heard this, I instantly, and with great excitement, recognized that this formula is precisely the desirable equation for me as well: "*study one, do one, teach one*." The ratio that allows me to be the best possible theater artist is: 1/3 research, 1/3 directing, and 1/3 teaching. If I do not dedicate enough time to research or if I teach too much or too little, my work as a director, as an artist, is compromised. Success, for me, lies in the balance among these three activities.

Study one, do one, teach one is a triad that I have carefully constructed in my own life in order to create the conditions for resonant theater. Study, or research, includes reading, writing, reflection, analysis, and unconscious rumination. A successful process, for me, is both active and passive. During the study phase, when not in rehearsal for a play or opera, I make sure to ensure enough time to study, rummage, and ruminate, to prepare for the next project. The composer, conductor, and polymath Leonard Bernstein said that it would be technically possible for him to compose a short sonata within a few hours through sheer willpower, but the sonata would not be any good. In order for the work to have substance, he said, it needs

to pass through what he called a trance-like state of unconscious processing. "It cannot come from the made-up, thinking intellectualized, censoring controlled part of my brain." After a certain amount of committed study, when the unconscious is sufficiently primed, the imagination must be left to do the necessary associative work.

This ratio of *study one, do one, teach one* is also crucial to the ongoing operations of SITI Company. One-third of our engagement is study, workshops, and cultural exchange, one-third is spent rehearsing and performing new work, and one-third is engaged in teaching. The SITI Company actors also work to advance their personal and shared understanding of technique and form through their own teaching at SITI's studios, conservatory and summer program as well as worldwide at academic and artistic institutions. This equilibrium is central to our well-being, productiveness, and usefulness.

In 1975, soon after graduating from Bard College, I enrolled in a two-year Master of Arts program at New York University, in a department now known as Performance Studies. It was there that I learned how to study in ways that continue to meaningfully impact my directing work. Rather than learning *how* to make theater, the program taught me to look at the theater through the lens of anthropology and sociology. To this day, in preparing for a new production, I pose the questions that I was encouraged to ask at NYU: What is a play? How does a play function in society? What is acting? What is performance? What does it mean to act or to perform? What is a rehearsal? What is an audience? Performance studies triggered an appetite in me for theoretical inquiry and intense study that continues to this day and affects most of my waking hours.

When I start rehearsals for a play, when I am in the *do one* part of the triad, the many months, and sometimes years, of study, subconscious associations, and preparation that I have engaged in, as I see it, give me nothing more than the right to walk through the door and into the rehearsal hall. After that, once the doors are closed and the staging begins, my engagement

is 100 percent intuitive. I hope that the study has equipped me with enough courage to let go of all of the preparation. I begin rehearsals by sharing my research with the ensemble, but then I let go of the ideas and concepts and start the collaborative work to craft and stage with an attention to the musicality of time and space as well as the emerging meanings.

The give-and-take between artistic and scholarly work extends to the period following the première of any new production. After the many crises of rehearsal, after the obstacles and inherent challenges of bringing a new project to fruition, there is now the opportunity to ruminate, analyze, and ultimately share new, hard-won insights with others. This sharing can transpire via writing, conversation, practical workshops or teaching.

Teach one became a key component to my work as a theater director very early in my career. If the arts were subsidized in the United States as they are in many European nations, I would probably not need to teach as much as I do. The extended rehearsal periods enjoyed in Russia, Germany, France, and the Scandinavian countries affords artists the deep exploration of subject matter that any serious theatrical endeavor demands. In these countries, the development of training, the shared research, and the essential experimentation can be carried out within the context of rehearsal. The standard three- to four-week rehearsal schedule, that is the norm in the United States, demands that everyone hits the tarmac running at top speed in order to stage the play with courage and alacrity. Most of my work in developing technique and in investigating content occurs, alternatively, in workshops and classes. At Columbia University, I study alongside my directing students. I am also able to give back from what I have learned in the context of previous *study one* and *do one*. Thus, now full circle, the reciprocal link between scholarly and artistic work can begin all over again.

The university environment provides an alternative to the lack of arts subsidy in the United States. The collegiality of fellow academics, the enthusiasm of young artists heading into

the field and a quiet campus environment can offer a respite from the relatively cutthroat commercial and not-for-profit world. But there must be a lively and mutually beneficial interchange between the profession and the academy, otherwise the relationship will be perfunctory.

5

The Presence of the Past

Mark Twain sent a letter to Helen Keller after she had been accused of plagiarism for her short story *The Frost King*. He wrote: "All ideas are second-hand, consciously and unconsciously drawn from a million outside sources When a great orator makes a great speech, you are listening to ten centuries and ten thousand men—but we call it *his* speech, and really some exceedingly small portion of it *is* his."

Every work of art contains a recognizable reference to another work, and this can be traced historically throughout the development of the arts and sciences. The task of an artist, much like that of a scientist, is to re-combine or edit existing materials in order to create something new. Ideas are adapted, extended or improved upon based upon the needs and circumstances of the particular moment. Combining knowledge, synthesizing information, and fitting things together that do not normally go together can lead to new perspectives and new creations. Fitting things together in unexpected ways allows new things to happen.

Copy. Transform. Combine

Copy, transform, combine, a term popularized by Kirby Ferguson, a New York-based filmmaker, is another powerful triad that, when lined up properly, can lead to resonance.

Ferguson proposed that we all build from the same materials, that creativity is not magic and that everything is a remix. In his web series, entitled *Everything is a Remix*, he cites examples from the historical development of musical forms, scientific and artistic advances, and technological breakthroughs to show that the formula for innovation is united in a consistent pattern of *copying, transforming, and combining*. Rock and roll, for example, was a result of copying, transforming, and combining the American Blues. The typewriter is a transformation modeled upon a piano. "The task of the artist," he says, "is simply to apply ordinary tools of thought to existing materials."

> Immature poets imitate; mature poets steal; bad poets deface what they take, and good poets make it into something better or at least something different.
>
> T. S. ELIOT

Copy

We are all building from the same basic materials. The initial step in Ferguson's equation, *copy*, requires an openness to disparate influences. We choose what feels both unfamiliar but most promising, and then we study it. Apparently, Hunter S. Thompson began his career by retyping the entire manuscript of F. Scott Fitzgerald's *The Great Gatsby* in order to get the feel of writing a great novel. Copying is how we learn. But rather than sticking with what is already known, it is necessary to reach outside of any immediate realm of influences. The beginning of real innovation is the consequence of internalizing external influences.

Reusing and recycling existing knowledge is an indispensable part of the creation of novel ideas. This process of copying, as well as imitation, is like learning a new language and then taking the first steps to putting the words into an order to create new personal meanings. We gather raw material, absorb it, and digest

it. While it is true that it is not possible to create anything new without a solid foundation of knowledge and an understanding of existing techniques, ultimately the research is filtered through the uniqueness of one's own experiences and taste.

Charles L. Mee Jr.'s plays are perfect examples of *copy, transform, combine*. As a playwright, he is known for his radical re-combinings of found texts. I have had the great privilege and pleasure of directing many of his plays. In a discussion about originality, he declared that what made his plays "his," was his own taste. He said, "There is no such thing as an original play. My plays are composed in the way that Max Ernst made his *Fatagaga* pieces towards the end of World War I: texts have often been taken from or inspired by other texts."

Transform

Transformation is gradual modification. The process of transformation requires diverging from what we have copied. Once we have chosen an idea, we start to create variations. Transformation allows for deviation through experimentation and expression in ways that have not been done before. In the course of this transformation, it is essential to welcome the associative process, to embrace the obstacles and resistances that naturally arise, and to make creative leaps. Major advances in art, in science, and in technology are usually not original ideas but emerge from a long history of progress by many different individuals.

Combine

The traditional understanding of innovation is the "Aha! Moment," like the spontaneous epiphany caused by an apple falling from a tree that supposedly led Isaac Newton to grasp the concept of gravity. But in contrast to this romantic notion that creativity happens in a sudden flash of inspiration, the truth is that innovation does not emerge in isolation from the

rest of the world, but, on the contrary, it is the result of recombining previously existing building blocks. And the most dramatic results occur in the interaction of disparate, often unrelated, ideas. Creative leaps occur in the combination of unconnected concepts. Innovation is the result of imitation, gradual modification, and merging multiple, unrelated ideas in new and creative ways.

Adding. Reshaping. Remixing

Take an object
Do something to it
Do something else to it

JASPER JOHNS

Generally, it feels absolutely fine to borrow or copy but it feels lousy to be copied. Steve Jobs admitted to stealing all of his original Apple innovations, at first saying, "creativity is just connecting things," but in later decades he spent millions of dollars on legal procedures against those who copied or stole from him. "I'm willing to go thermonuclear war on this," he vowed of the patent lawsuit Apple filed against cellphone manufacturer HTC.

I believe that the creative act does not happen in a vacuum and that the quest for originality is vastly overrated. I also know in my bones that to *copy, transform, and combine* requires not only openness to the substantial influences of the past, but also the consistent heat of curiosity and the stubborn persistence of investigation, trial, and error. The willingness to learn and an appetite for study fueled by vigorous and genuine curiosity leads to real creative innovation. Ideas are everywhere, but it is the act of processing and connecting ideas together that produces the kind of creative leaps that have an impact and resonance in the world. It is not enough to simply *copy, transform, and combine*, it is also necessary to bring a point of

view and to experiment with the endless variations and combinations.

When we try to pick out anything by itself, we find it hitched to everything else in the universe.

JOHN MUIR

The composers Max Richter and John Adams both released albums in which they plunder, indeed copy, older works in order to reclaim them, reify them for the present moment. Max Richter's album *Recomposed* re-imagines Vivaldi's *Four Seasons*. He described his process as "throwing molecules of the original Vivaldi into a test tube with a bunch of other things and waiting for an explosion." John Adam's more recent *Absolute Jest* reworked Beethoven's late string quartets and it is a great example of *copy, transform, and combine*. "I wanted to put them through a 'John Adams machine,'" Adams said about the Beethoven quartets in a recent interview. The idea for *Absolute Jest* arose during a performance of Stravinsky's *Pulcinella*. Stimulated by the way that Stravinsky absorbed musical artifacts from the past and worked them into his own highly personal language, Adams decided to follow his own obsession with late Beethoven to create a new work. In order to get under the skin of the composer, he took small harmonic fragments from Beethoven and put them through the factory of his imagination: an act that, according to him, stimulated his invention.

At the other extreme, when the brilliant American director Robert Woodruff is preparing to work on a new production, he goes out of his way to *avoid* the influence of other directors' productions. Although his research and his work with dramaturgs is always rigorous and extensive, he personally sidesteps seeing other productions of the play. He wants his approach to be fresh and singular. He does not *want* to be influenced by choices made by other directors.

My own approach to directing a play is different from Robert Woodruff's. I am a forager. I choose plays and subject

matter based upon who and what I want to spend time with through the preparation, research, and process of rehearsal. Before directing a classic play or opera, I invariably search far and wide to find out how other directors and other companies have handled the same work. How did they approach the specific challenges of the drama? How did they contextualize the world of the play or opera? How did they translate the ideas and the narrative into the languages of time and space? I am not afraid of being influenced by what I discover. I want to take it all in. I want to internalize the lessons accrued by the study and investigation and I want to be altered by this intra-action.

Connections and Influence

The influence of others is what keeps us connected to one another and to those who came before us. Humans are replicators. Not only do we replicate the species biologically, by having offspring, we also replicate and put a new spin on ideas, or what evolutionary biologist Richard Dawkins calls memes. A meme is an idea that spreads from person to person within a culture. Memes carry cultural ideas, symbols, or practices and can be transmitted from one mind to another through speech, gestures, rituals, writing, or mimicry. We are meme-making-machines and we are communicators. We are signaling to one another through the haze.

In my own process, although I actively look for influence from other theater artists who previously tread the same terrain, I also must be open to the discoveries and the transformations that happen in the heat of engagement, in rehearsal. SITI Company rehearsals are motivated by a deep desire for discovery and by the belief in the creative alchemy that can be triggered by shared listening. We approach the rehearsal as a kind of conjuring, an attempt at an uninterrupted connection with our predecessors. This methodology requires deep listening by everyone involved, plus trust, cooperation, and openness to influence.

Klaus Michael Gruber

Artists and productions that I initially understand the least tend to exert the most lasting influence over me. In preparing to direct Euripides' *The Bacchae* in 2018, I closely studied the 1974 Berlin version of Euripides' play directed by Klaus Michael Gruber. I had not seen the live production, but I was lucky to have experienced a number of other Gruber productions in Europe before he died in 2008. The memories of each one remains haunting and somehow permanently etched upon my body and in my memory. Gruber's work has influenced my own development as a director perhaps more than any of his contemporaries. This production of *The Bacchae*, and Gruber's work in general, is known for its incomprehensibility and mysterious atmospheres. Even on DVD, Gruber's version of *The Bacchae* is the one that, compared to any other production of the play, I understood the least. It was mysterious and yet plugged into an energetic and authentic vitality. From experience I knew that I could learn the most by studying this production.

In 1981, while directing a play with acting students in West Berlin, I learned that Gruber was in rehearsal for a production of Pirandello's *Six Characters in Search of an Author* at the nearby Freie Volksbuhne. Gruber rarely allowed observers in his rehearsals and this was no exception. But I discovered a secret way to be present. Our scenic design was built in the shop of the Freie Volksbuhne, which was located directly above the stage where Gruber was rehearsing. One evening, while visiting the shop to look at the progress of our design, I discovered a hole in the floor through which I could look down at the stage. I lay on my stomach, looked through the hole and, if truth be told, did not see a lot. An actress was moving around, holding a candle. I strained to hear. I strained to see. Then I returned several evenings in a row to lie on my stomach and soak in the atmosphere. What did I learn? I do not know. But something definitely happened.

Despite all of my extensive research in the year preceding the launch of rehearsals for our 2018 *Bacchae*, in a new

translation by Aaron Poochigian at the Getty Villa in Los Angeles, the chief influence upon our production turned out to be the play itself. Euripides kicked us regularly, fighting back against the imposition of too many ideas about interpretation and staging. In this process, I learned that if we listen carefully to the play, if we are deeply engaged in the archeological excavation of an ancient play as great as *The Bacchae*, it will not allow us to mitigate its power. It will talk to us from the past. It makes its influence real.

John Cage

> There is never a moment when sound is not available to the ears. However, when our minds are full of fears our concern is taken away from hearing. We stop listening even though there is something to listen to all the time.
>
> JOHN CAGE

The composer John Cage has been a particular touchstone, influence, and inspiration for me over the past four decades. Through his example, I learned to enjoy the spaciousness of deep listening as well as the taste of freedom from unconscious repetition and outmoded assumptions. In both practical and spiritual ways, his innovations and his life force continue to affect my artistic processes. At certain stuck moments in rehearsal, I say, "Let's Cage/Cunningham this scene!" By this, I mean create the staging separately from the text and then we put the two together and discover the new meanings and possibilities that emerge from the juxtaposition. The process requires everyone to give up a little bit of control in order to make space for discovery. Also, through Cage's example, I learned how to walk the thin line between control and chance in my relationships with actors and designers and how to allow the different elements in the theater—the lighting, the sound, the text, the movement—to enjoy agency and independence. But perhaps most profoundly, Cage taught me

how to give the audience a creative job in the theater. Because he was not interested in art as self-expression or as direct communication between artist and audience, Cage attempted, in his art, to create the conditions for the audience to "sober and quiet the mind thus making it susceptible to divine influences."

Through the example of his life and his mischievous provocations, Cage demonstrated how to let go of the fears and assumptions that accumulate about what is permissible and possible. He taught me not to be afraid of the absurd, to look for surprise and the unexpected and to approach the world with the attitude that things are simply *not* what they seem to be. He reminded me to keep asking questions. He taught me about delight. Through his example, I, too, attempt to create the conditions for uninterrupted connection, agency, permission, and freedom in the rehearsal hall and to allow the audience as much sovereignty as possible during a performance. Although it is always possible to manipulate an audience's response, or predetermine where a laugh or where tears happen, the point is to be an advocate for the audience's autonomy.

Viewpoints

I invented nothing new. I simply assembled the discoveries of other men behind whom were centuries of work. Had I worked fifty or ten or even five years before, I would have failed. So it is with every new thing. Progress happens when all the factors that make for it are ready, and then it is inevitable.

HENRY FORD

In 1979 I was invited to join the faculty of the Experimental Theater Wing (ETW) at New York University where I remained as an adjunct for seven years. In many ways, teaching undergraduates at ETW became my own degreeless graduate school. At first, I was unsure of what to teach. Still in my mid-

twenties, my work up until then had been hardscrabble inventions, mostly on the streets and rough spaces of downtown New York. Ron Argelander, the founder of ETW who invited me to teach at NYU, encouraged me to engage the students with the kind of work that he had seen me create in the downtown theater scene. It was at ETW that I met fellow faculty member Mary Overlie, the choreographer and the inventor of what she in those days called The Six View Points. We became good friends and we worked together on several productions with our students. We co-directed a site-specific piece entitled *Artourist* and she choreographed the dances for my production of *South Pacific*.

When Mary introduced me to her Six View Points, I was galvanized, hooked. The students, empowered by the parameters of Mary's View Points (Space, Shape, Time, Emotion, Movement, and Story), relished the freedom to make things up themselves, rather than wait for a director to tell them what to do.

To me, much of the theater at that time felt staid, literal, and conservative with the exception of some courageous downtown artists and companies including the Performance Group, Mabou Mines, and Richard Foreman. But the dominant means of theater making felt patriarchal and hierarchical, an approach that simply did not sit well with me. Rather than using the role of director as a means of domination and control, I yearned for effective ways to collaborate with actors. Mary's work directly addressed fundamental issues that I felt were sorely missing from the theater world. Mary's own discoveries were influenced by her contact with significant dance-makers of the time.

My work with the Viewpoints, over the years since I met Mary, progressed within the context of directing plays, conducting workshops, teaching, and, in general, working with hundreds of actors in the heat of creation. The basic principles that I learned from Mary underwent changes in the form of the stages of *copy, transform, combine* and morphed eventually into something other than what she originated. In time and with constant adjustment to what I was absorbing and testing, Mary's "Space, Shape, Time, Emotion, Movement,

and Story" drifted away from me. Eventually I found it practical and useful in working with actors to differentiate "Spatial Relationship, Shape, Architecture, Kinesthetic Response, Repetition, Tempo, Floor Pattern, Duration, and Gesture." And then, in numerous explorations in the art of speaking, I also arrived at the Vocal Viewpoints: "Pitch, Tempo, Repetition, Timbre, and Silence."

Looking back now, I can clearly see that my own work with the Viewpoints underwent a process of *copy, transform, combine*. When different ideas are combined together, one idea can broadside the other and result in new and dramatic outcomes. I was not only influenced by Mary Overlie's innovations, but also by those of a myriad other external input that were consistently moving in and out of my sphere of experience. Connecting ideas together and merging multiple, unrelated ideas in new and creative ways require an ability to spot the potential for creative leaps. My one regret, and in fairness to Mary Overlie's original innovations, is that I wish I had changed the name of our work, that was originally inspired by her groundbreaking vision, but that has transformed so radically over time.

All great works of music, art, science, and culture have been inspired by the world's history of innovation. We assemble and edit what our predecessors have brought into being and contextualize it for audiences today. Everything that we create is influenced, either on a conscious or subconscious level, by our relationships and by what we have seen, felt, read or listened to. We expand upon those experiences by adding, reshaping, and remixing our own interpretations and as well as our particular points of view.

Agency

I'll tell you what freedom is to me: no fear. I mean really, no fear!

NINA SIMONE

In the fields of sociology and philosophy, agency refers to the engagement of an individual within a social structure and their capacity to act within a given environment. Society is a social construction that requires the cooperation of individuals connected through social relationships. Even though an individual is shaped by the existing social structures, they nonetheless have the ability, the agency, to make decisions and express them through conscious behavior and action.

High levels of agency represent an individual's ability to understand personal action in terms of the consequences and implications. Low levels of personal agency represent the tendency to see one's actions in terms of the details or mechanics. These two levels of agency can work towards positive creative acts in the world. But they can also work towards destructive ones.

In his Los Angeles studio, the architect Frank Gehry oversees the design and realization of dozens of international projects simultaneously, thereby exercising a high level of personal agency. His associates and assistants, in comparison, enjoy a lower level of agency. Their task is to tend to the mechanics and details of given projects in the creation of what can become beautiful creative acts in the world. In contrast, and towards the destructive, Donald Trump exercised a high level of agency over the circumstances of his rallies. The Trump followers exercised a low level of agency through their aggressive, reactive, often impulsive behavior at those same rallies. They feel agency, but their territory of freedom and consequence is narrow.

Agency does not simply arrive at one's doorstep; rather it is earned by looking out into the world to find role models and inspirations, followed by personal identification, hard work, repetition, determination, sustained practice, and, perhaps most importantly, opportunity. The actress Viola Davis remarked in an interview that Meryl Streep did not become the great actress that she is simply by being Meryl Streep; rather, she came into her abilities through the particular roles she was offered. Without *Sophie's Choice*, *Kramer vs. Kramer*, or *The*

Devil Wears Prada, she would not have had the opportunity to advance and grow. Davis continued, "You have to separate opportunity from talent. People feel that if the roles are not there that that means that there's no talent out there. That's not true. What's true is that if you create those narratives, then those roles can open up to people who are waiting in line." She attests that the people who are in the positions of power are the ones who can make the decisions that provide the agency for talent to emerge. "You can't be a Meryl Streep if you're the third girl from the left in a narrative with two scenes." Davis thereby makes a plea for artists of color to be offered opportunity. "You write it and we will come. We will show up."

But ultimately, producers and audiences not only in film, but also in theater, in classical music, and in all of the arts, must be willing to take chances and broaden their perspectives. Until then, equality will continue to be deemed too unprofitable in the eyes of those who hold the purse strings and audiences will continue to be conditioned to expect only certain embodied representations. In this way, artists are denied agency by the very systems that are meant to support and encourage them.

The moment that nineteen-year-old Stefani Joanne Angelina Germanotta first encountered David Bowie on the cover of his record album *Aladdin Sane*, her perspectives and attitude were transformed forever. "It was an image that changed my life," she said. "It was the beginning of my artistic birth." She put the vinyl record onto a record player that sat on the stove of her tiny Lower East Side apartment and began to evolve into the Lady Gaga that we know today. She said, "I had never heard somebody with such a strong musical perspective that combined so many different genres and types of music in such a boundless way. I had never heard or seen anyone that was so limitless in his vision where music could go and how you can change the world in a single moment by creating some piece of theater that is just otherworldly . . . From the moment I saw that cover my life changed forever and I started to dress more expressive of how I wanted to be. I started to be more free with my choices. I started to have more fun." Lady Gaga seized the

permission, provided by the connection to David Bowie's life and work, to become who she is today. He gave her the freedom to move and the inspiration to act.

The question that I often ask myself is: What stops me? What prevents me from being a free agent in my own environment? And what, on the other hand, provides agency? As artists we are all beholden to the journeys undertaken by our predecessors. What we inherit from them is not only technique, but also permission and encouragement to take action oneself. The forays, experimentations, discoveries, and accomplishments of our heroes are what give us the go-ahead to maneuver more freely. Agency is also dependent upon the opportunities that are presented to us.

Probably what stops me is my own fear of doing something differently. What stops me is the accumulated assumptions about how things are supposed to be done. What stops me are inherited ethics, moralities, and outmoded hierarchical structures that have outlived their usefulness. What inhibits me is fear of failure.

Agency is an individual's power to make choices and to enact them in the world. This capacity to make choices first requires the personal *belief* that humans can, in fact, make decisions and enact them. Some people simply believe that they are able to do big things. Perhaps they are not concerned with success or a particular outcome. Or maybe they have confidence in the outrageousness of their enterprise. This belief implies a measure of direct control over their own behavior. But my own ability to take action, to be effective, and to assume responsibility for my actions in the face of conflict or change entails not only the awareness of what I can do but the awareness of what I *think* that I can do. I must find a way to give myself permission. And then, because I am a theater director and because my work involves many other people, I must provide agency to a room full of collaborators. The essayist Michel de Montaigne observed that in painting, "sometimes the work breaks free from the painter's hand, surpassing his ideas and understanding, leading him to be astonished and profoundly moved."

Agential Realism

"We" are not outside observers of the world. Nor are we simply located at particular places in the world; rather, we are part of the world in its ongoing intra-activity.

KAREN BARAD

Karen Barad, a physicist who works with philosophy and feminist theory, questions the very notion of individuality. Drawing inspiration and concepts from quantum physics, post-structuralism, and feminist theory, she developed a theory that she calls "agential realism." Rather than a person being an independently existing individual, Barad proposes that the world is made of entanglements of "social" and "natural" agencies, where the distinction between the two emerges out of specific "intra-actions." Intra-actions configure and reconfigure relations in time and space. Her ideas have been applied to environmental studies, fashion studies, and archeology. Central to agential realism is the refusal to accept the dichotomy between epistemology (logic) and ontology (experience). According to Barad, we are not separate from the world around us, and the world is not separate from us. "Agency," she wrote, "is not held, it is not a property of persons or things; rather, agency is an enactment, a matter of possibilities for reconfiguring entanglements.... Agency is about response-ability."

Barad's analysis that we are not actually individual until we come into contact with some "other" is both profound and useful when considering one's own life and is groundbreaking in terms of the theater and all notions of character. The implication is that we are simply a collective of entangled matter and only become conscious of our individuality when we are positioned against something else. "When we come to the 'interface' between a coffee mug and a hand, it is not that there are x number of atoms that belong to a hand and y number of atoms that belong to the coffee mug." Separateness

and difference emerge only in specific contexts and are always established in relation to the other.

I find Barad's theories both groundbreaking and practical in art as well as in life. Her ideas remind me that we do not create in a vacuum and that our identities as well as moments of performance are always formed in "intra-action." We are able to think laterally, with others, and act in concert with the ever-changing material surroundings, that are not, in fact, separate from us. Attachments keep changing and are never static. Rather than having a frozen identity and a fixed individuality, we can experience the ongoing performance of the world in a dance of both intelligibility and unintelligibility. If we think of language as discourse, storytelling can exist as a web of entanglements.

> The very nature of materiality is an entanglement. Matter itself is always already open to, or rather entangled with the "Other." The intra-actively emergent parts of phenomena are co-constituted. Not only subjects but also objects are permeated through and through with their entangled kin; the other is not just in one's skin, but in one's bones, in one's belly, in one's heart, in one's nucleus, in one's past and future. This is as true for electrons as it is for brittlestars as it is for the differentially constituted human.
>
> KAREN BARAD

Viewpoints and Uninterrupted Connection

The Viewpoints is a practice of uninterrupted connection that requires skill, patience, and sustained attention which can be acquired over time, with diligent practice and the activation of *conscious delay*. Several years ago, I conducted a ten-day Viewpoints workshop at PlayMakers Repertory Company in

Chapel Hill, North Carolina with members of the PlayMakers Company and graduate students from the University of North Carolina. At the time, I was furiously studying neuroscience in preparation for a SITI production about the brain entitled *Who Do You Think You Are*. Bonnie Raphael, the vocal coach at PlayMakers and a long-time friend, mentioned that the neurophysiologist R. Grant Steen lived in Chapel Hill and taught at the university. When Bonnie uttered his name, I let out a little gasp because I was just then reading Steen's insightful and readable book *The Evolving Brain: The Known and the Unknown*. Bonnie generously arranged for the three of us to have dinner together. After good food and an excellent conversation about the state of neuroscience, I invited Professor Steen to attend a public Viewpoints showing to mark the end of the PlayMakers workshop later that week. He arrived at the theater and sat through the open Viewpoints session. Afterwards, during the Q and A, he raised his hand and said: "What I am seeing onstage is how the brain works!" He went on to explain what he meant.

Much later, I emailed Professor Steen to ask if he remembered his exact reflections on that day and he immediately wrote back with great detail and eloquence. Here is his reply:

What I meant in my comment was that the way people related to each other on stage at first seemed random. But, as I watched, I began to discern a pattern and to see the rules governing those interactions. I didn't know all of the rules—I know you explained them before the exercise, but it was all quite new to me and all that I remembered was that there were explicit instructions—but as I watched carefully I could begin to infer those rules in action.

Subsets of people seemed to behave in different ways, as if they had interpreted the rules differently. As I watched carefully, it seemed that I could classify types of people-neurons as well as styles of interaction between them. Some people were awkward, some fluid, some people seemed to reflect back what they saw in the other person and some

people seemed to have internalized the rules and made something different from them. In other words, the rules had been reinterpreted and the people-neurons were showing emergent properties that had not been built into the system in the first place.

Finally, connections were made and unmade between people, the way that neurons can interact or be quiescent. Sometimes an interaction would flare up and be quite active; sometimes an active interaction would slow and cease. Observing from the outside, one could only wonder at the separate motivations for the interactions.

It all began to seem like a microcosm of the brain, but one that could be understood eventually. I am not convinced that the human brain can ever truly understand itself. We can certainly come to understand the plumbing and wiring—the perfusion of the brain with blood and the physical connections between neurons. But the emergent properties of the brain seem likely to defeat our understanding. I think we will need a bigger brain to understand the one we already have.

6

Dissonance

Dissonance for Resonance

The truth is that our finest moments are most likely to occur when we are feeling deeply uncomfortable, unhappy, or unfulfilled. For it is only in such moments, propelled by our discomfort, that we are likely to step out of our ruts and start searching for different ways or truer answers.

M. SCOTT PECK

Resonance, which should not be confused with consonance, requires dissonance. Resonance does not arise from harmony, but rather it develops out of tension, sorrow, discord, strife, struggle, irrationality, and everything that resists our will. Dissonance is often associated with harshness, unpleasantness or unacceptability. But dissonance does generate a *real* experience. The theater director Richard Foreman regularly placed string or plexiglass between the audience and the actors because he believes that the barrier actually intensifies the relationship between the stage and the audience. According to Foreman, art should sharpen the mind and focus the audience's attention. "For me," he said, "that's the only important thing in art, to be confronted with something that makes you really see It."

Difficulties and obstacles can serve to bring one closer to resonance. In the text of a play, dissonance may be introduced through opposition such as contradicting narrative threads, or

characters encountering obstacles. Whether in the dramaturgy, design, staging or acting of a production, the dissonance within resonance might disorient or disturb the perceiver, but it can also create a double emotional structure: Tears through laughter or laughter through tears. Pleasurable pain or painful pleasure. Grief and joy. Sad music that lifts one out of depression rather than plunging one into it. It is in encountering "the other" and integrating the dissonance that one approaches resonance.

During rehearsals for an opera that I was directing in Washington DC, the conductor, a highly experienced musician, an eminent scholar, and a consummate artist, took me aside one evening after a particularly difficult rehearsal and she spoke sternly. "You are losing the singers." Her unexpected criticism arrived as a harsh blow. At first, I was offended. "How dare she say this to me!" I thought. Then came denial: "She's wrong, I am not losing the singers."

But when confronted, I am aware that at first my ego rises up and reacts defensively and I want to do anything to escape that lousy feeling. Like a rusty iron barrier, my pride becomes an obstacle to any forward motion. The impasse feels simply horrible. Predictably, after the initial blow, my pride and ego wounded, I blame external circumstances: "Why am I being treated this way?" "I don't deserve this." "I am doing the best that I can." I clench and freeze, wanting to keep things as they are in order to avoid taking personal responsibility for the situation. Then, I start to entertain self-sabotaging thoughts: "I am a terrible director." "I am a terrible artistic director and a terrible artist."

Later on that evening I felt myself careening into a chasm of doubt and self-loathing. I felt stuck and miserable. But my body was telling me that I needed to pay attention to the criticism in order to learn and grow from the situation. The dissonance triggered by the conductor's criticism fairly quickly led me to positive action.

Deep down, I knew that there was truth in it. Indeed, I had not sufficiently thought through the end of the opera. I was depending upon the spur of the moment inspiration and the

creativity of the singers rather than preparing a back-up plan in case nothing had gelled. The conductor triggered dissonance in me by drawing attention to a general weakness in my work as a director. Her pointing allowed me to see the problem clearly. Now I had a choice: I could either turn away from the issue or I could face it.

I believe that the opera and even my own skills were improved thanks to this crisis, this episode of dissonance. Ultimately, I was able to step back and look at the production more globally and return with a new plan. I walked into rehearsal fortified with determination and ready to lead the singers more effectively.

Worse is Better

A powerful moment onstage, or a compelling sound in a musical composition, or an arresting object in a visual art installation is rarely flawless. Rather, usually there is something about it that is slightly "wrong." The resonance of the work is increased by its inherent dissonance. In 1770, Voltaire wrote that "the best is the enemy of the good" (*le mieux est l'ennemi du bien*). In a similar spirit, present-day software engineers use the term, "worse is better" meaning that quality does not necessarily increase with functionality and that there is a point where less functionality ("worse") is a preferable option ("better") in terms of practicality and usability. Since the late 1990s in the music industry, digital sound processing made pitch correction possible. Auto-Tune is software that can fix singers' pitches in recording or in concert. Unfortunately, the perfection does not necessarily lead to resonant performances. Auto-Tune adjusts the singer's every tone with unyielding, unvarying precision, squarely in the mathematical center of the note. But in every form of vocal music, the scale is actually a framework for expressive interpretation, not a system of regimentation. Resonant emotional expression in vocal music, involves the deft, intelligent manipulation of pitch. A skilled

singer knows how to shade a moment in a song by, say, hovering near the bottom of a note, within the note, in tune, but just below the center of a tone. The art of music is contained in those variations.

Many of the world's greatest painters, including Titian, da Vinci, Michelangelo, Rembrandt, Paul Cezanne, Alice Neel, Piet Mondrian, and Sol LeWitt, left their works purposefully incomplete. These paintings are especially cherished because the incompleteness allows the viewer to feel closer to the artist. Art curator Kelly Baum described the attraction to the incomplete: "An unfinished picture is almost like an X-ray, which allows you to see beyond the surface of the painting." The artist is exposed and vulnerable, which somehow makes them more relatable, more fallible, more human.

While it is true that some artists go to great lengths to achieve the perfect figure, the perfect score, or a flawless performance, the results are not necessarily ones that audiences respond to. On the other hand, great meaning can be found in imperfection, irregularity, and impermanence. Many works of art derive their character from their irregular, off-kilter, or incomplete nature. Rough-hewn objects can hint at their inevitable decay. There are cultures around the world that learned to abandon rigid and obsessive perfectionism in order to embrace imperfection. Artists in these cultures deliberately introduce defects into their works to remind themselves that flaws are an integral part of being human.

For example, the Japanese aesthetic concept of *wabi-sabi* centers on finding beauty in a conscious acceptance of transience, imperfection, and incompleteness and celebrates asymmetry, roughness, simplicity, economy, modesty, intimacy, and the integrity of natural objects and processes. *Wabi* refers to the beauty found in asymmetry and imbalance and *sabi* expresses the beauty of aging and the impermanence of life through the passage of time. A classic example of *wabi-sabi* is found in pottery, specifically the art of *kintsugi*, where cracked pottery is repaired using gold lacquer as a way to celebrate the beauty of the damage rather than hiding it. The fragility, the

brokenness, and the individuality of each object is deeply appreciated.

In Navajo culture, rug weavers leave little imperfections along the borders in the shape of a line called *ch'ihónít'i* or "spirit pathway." The Navajos believe that when weaving a rug, the weaver entwines part of her being into the cloth. The spirit pathway allows this trapped part of the weaver's spirit to safely exit the rug.

The French *jolie-laide* translates literally as "pretty-ugly," but can connotate something more lyrical, even transcendent. *Jolie-laide* celebrates the beauty of a bump on the nose or eyes that are set too closely together or a jagged smear of a mouth. As an endorsement of the poetics of irregularity, *jolie-laide* jogs us out of our reflexive habits of looking and assessing by embracing the aesthetic pleasures of the visually off-kilter. Because we tend to gravitate towards what is idiosyncratic or even eccentric, *jolie-laide* catches our attention.

No matter how much we study, strive, and train, we should not expect or even want perfection. Instead, our goal can be a glorious and lively imperfection, a purposeful dissonance, that spills over into life. In whatever way we choose to study and to train, what we do will be imperfect. But we can learn to appreciate this unstable imperfection as beautiful and we can derive enduring pleasure from the mixture of form and roughness, resistance and gravity, breath, and life. Physical presence is untheoretical, unpredictable and it is rough because nature and culture are intimately part of each other. And our failures feed information into the total creative process. If we are lucky, we will make something new and resonant that feels as though it has always been there.

Investigate the Fear

One of the many reasons that I chose to work with a company for the past thirty years is that I am consistently fed and challenged by the particular dissatisfactions of my colleagues.

The members of SITI Company are rarely satisfied. Often in rehearsal, just as we reach a solution or an understanding about some aspect of a scene or project, just as we think that we have arrived at a solid grasp on a bit of staging or a key moment, inevitably someone says, "Yes, but what is it *really*?" While this can feel like an annoying question, I know that it is also a necessary one. The hermeneutic process of "What is it? Yes, but what is it *really*?" has become a useful rehearsal method. Together we lean into our shared dissatisfactions. And this sometimes unwelcome dissonance proves again and again to be the pathway to surprises and solutions.

In 1999 I directed *Cabin Pressure*, a devised piece, with SITI Company at Actors Theater of Louisville, a work based upon the many faceted aspects of the actor–audience relationship. For one particular scene we decided to re-create the actors' experience of being backstage during a performance. Working together, we arrived at what felt to me to be a solid structure for the scene, quite amusing and a little bit reminiscent of Michael Frayn's play *Noises Off*. After rehearsal that day, feeling quite satisfied with our work, I returned to the Mayflower Apartments where the company was housed. At about two o'clock in the morning I awoke to a quiet sound of knocking. When I opened the door to the apartment, SITI Company actress Ellen Lauren stood outside in the hallway with a boom box in her hand. "May I come in?" she asked. She entered my dimly lit living room, sat down, switched on the piece of music that she had brought with her, and began to describe in great detail and feeling what an actor *actually* undergoes when standing backstage waiting to go on during a show. Riveted, I was transported through her words and the haunting music into the private and singular world of an actor's subjective experience during performance. Ellen's depiction of the atmosphere backstage resonated with me. Needless to say, the following day in rehearsal we jettisoned our delightful *Noises Off*-style scene and created a new one, far more poignant and truer to the spirit of *Cabin Pressure*.

Despite such experiences, I too easily forget that dissonance and dissatisfaction in the rehearsal room are central to the creative process. It is natural and sometimes even sane to run away when danger signals and uncomfortable feelings arise. But the artistic process requires the courage to face vulnerability and to embrace imperfection. This is what makes what we do magnetic. Extreme Action choreographer Elizabeth Streb said that in order to succeed, her performers' curiosity must be greater than their fear. Her statement is a reminder that fear, discomfort, and the feeling of fragility does not have to stop me and that my own tendency to dispel the problem and to keep equanimity is misguided. Yes, the fear is real, but it does not have to overpower the creative process. In moments of panic I try to remember: Get curious! Investigate the fear. And it turns out that during the moments of deep engagement I am not actually afraid. I am taking interest.

Embrace the Dissonance

The only book that is worth writing is the one we don't have the courage or strength to write. The book that hurts us (we who are writing), that makes us tremble, redden, bleed.

HÉLÈNE CIXOUS

In 1970, director Ric Zank, together with the administrator Gillian Richards, founded the Iowa Theater Lab at the University of Iowa's Center for New Performing Arts and, seven years later, settled into an old Catskill mountain resort on eight acres of land outside of Catskill, New York. Until arriving in Catskill, the company had been fairly nomadic, moving between Iowa, Baltimore, and New York. During the late 1970s and early 1980s, Ric and his company exerted a significant influence on me as well as on many of my colleagues. The work of the Lab was physical, imagistic, emotional, and, to me, unforgettable. Also, Ric's

fearlessness in facing difficulties and obstacles became a beacon for me.

In 1975, during rehearsals for a new production of *Moby Dick*, the brilliant and physically masterful actor George Kon, who Ric had cast as the whale, grew increasingly aggravated and upset. His frustration intensified and escalated until one day, all of a sudden and in a great fury, George literally ran up a wall of the rehearsal hall. Most directors, concerned about the situation, would have called the rehearsal to a halt in order to talk through George's frustrations and dissatisfactions, identify the root of the problem and calm him down. This is not what Ric did. Rather than calming everyone down, he embraced the dissonance and at a particular moment in the production, George Kon had to charge up a wall, an action that, at each and every performance, captured the power, energy, and majesty of the whale.

Differentiation of Time

As a young director, I was fascinated and intrigued by Ric Zank, the Lab, their intense physical training, and their productions. In addition to *Moby Dick*, the company created and toured a number of remarkable devised works including *Dancer Without Arms*, *Judas Pax*, and *Sweetbird*. I thrilled to the poetic, physically demanding and erotic nature of each production. When I got to know Ric personally, the Iowa Theater Lab had just moved to Catskill. In 1979, Ric, who believed in creating a community to provide a working environment and support for like-minded artists, generously allowed me to bring three actors to Catskill to live and rehearse in the house and on the grounds of the Lab's home. Over the course of two summers, I also became part of the Lab team that put together *August Moon*, a three-week-long summer theater festival. During those two years, Ric took me under his wing and taught me about aesthetics, directing, music, film, literature, and acting. I was also able to

watch him in action with his own company. Always able to cut through niceties for the good of the work, Ric never appeared to be afraid of conflict or dissonance.

One evening in Catskill, Ric invited me into his music room to play for me a number of different recordings of Gustav Mahler's unfinished *Symphony No. 10*. His final symphony, it was written by Mahler in 1910 while haunted by the knowledge of his failing heart and his wife's affair. Mahler died before completing the work. Ric wanted me to hear in particular how great conductors interpreted the same piece differently, a piece that music critic Tim Ashley calls "one of the most troubling, paradoxical works in musical history." Together we listened to orchestras under the batons of Pierre Boulez, Claudio Abbado, and a newly released version conducted by Simon Rattle. Listening, I fell under the spell of Ric's intense love for the music and his feeling for the nuances of conducting. His passion for music, film, and art clearly influenced his own work as a theater director and, through his example, I began to feel how a director's work, much like a conductor, is about the differentiation of time, moment by moment.

In listening to *Symphony No. 10*, I was tempted to guess at the motivations and processes behind the creation of the work. I believed that I could hear Mahler's dissatisfaction, perhaps linked to his restless search and questioning. I imagined his nagging uncertainties about living in flux, in a finite body, with an unfaithful wife and the death of a child. Where was his world headed? In the music, I heard moments of almost unbearable intensity and unrelenting showers of emotion. The piece begins in a romantic, rather familiar nineteenth-century manner. Mahler seems to be roaming around, searching through fragments of his past and building very gradually towards what portends to be a personal breakthrough, finally with a chord that, to me, seemed to encompass the entire twentieth century. Did Mahler, in writing the symphony, overcome his dread of death and his love for his errant wife? We will never know. What I do feel

in Mahler's final piece is a colossal unrest and a profound dissatisfaction.

Obstacles

On any given day, a narrow margin of personal equilibrium and balance is required in order to be productive and innovative. With sufficient food and protected from danger, when provided a modicum of support from family, colleagues or loved ones, when not in debilitating pain, when equipped with the tools to tell a story, it just may be possible to be creative. It also helps to be part of a culture that receives artistic output in good faith and feels that what art achieves is necessary for everyone. With all of these factors lined up properly, there is a chance to be creative.

But even amidst the best external circumstances, other obstacles arise, and these are personal, intimate, and interior. We all experience moods, shifting from anxiety to worry, apathy to boredom. Psychologist Mihaly Csikszentmihalyi recognized that arousal and control are the key ingredients in the creative act, and he called this psychological concept *flow*. Arousal is the result of an optimal balance between incoming stimulations and the nervous system's ability to assimilate them. Control relates to technique and it is earned through long and steady practice. In Csikszentmihalyi's formulation, flow can be the consequence of aligning arousal and control.

Generally, I find pleasure in action and I crave challenges that require me to respond, building upon the tools and techniques that previous creative endeavors have instilled in me. Without regular obstacles and the concomitant energy and inventiveness needed to tackle them, I tend to shut down, physically, intellectually, and emotionally. As a young director, the obstacles and difficulties that I encountered in the process of realizing new projects became the foundation for a life in the theater. The toughest and the most

dissonant experiences were also the most formative and indispensable.

Flashes and Blazes

In 1980 I was invited by Steve Wangh and Suzanne Baxtresser and their newly formed theater company Present Stage to direct a parade in Northampton, Massachusetts. I accepted on the condition that I could reverse the normal conventions of a parade. Rather than the audience on the sidewalks and performers moving along the street, I proposed that the audience walk the streets while the staged events would take place in shop windows, rooftops, and parking lots along the way. My proposal was accepted, and I began to work towards the big event, scheduled for August 10 of that year.

To drum up interest in the parade, I decided to stage ten distinct performance events on the ten evenings leading up to August 10. I called these performances *Flashes*. About twenty local actors and dancers agreed to function as a core-group, to co-create and perform in the ten *Flashes*. I led regular workshops with them, and gradually the group began to coalesce into what felt like a company. During the month leading up to August 1, I also spent each day preparing for the big parade, convincing diverse groups from around Northampton to participate and I worked with them to establish the nature of their participation. The groups included a Polish marching band, the Northampton fire department, an association of veterans of foreign war, an equestrian club, an alliance of women against violence, and many, many others. Some groups wanted me to oversee and direct their specific contributions and others simply promised to show up on the day of the parade prepared to perform. Each day started early and ended late in the night.

As August 1 approached, I had prepared a basic scenario for all of the ten *Flashes*, but it was not until the day of each performance that we actually staged the piece. Rehearsal began

at five o'clock on the day of the *Flash* and at eight o'clock an audience assembled, ready for a show. Each evening's *Flash* started in Pulaski Park in the heart of downtown Northampton and began with the same opening gesture. The actors and dancers entered the park to perform a unison dance together, accumulating movement phrases based upon the physical vocabulary of wielding the daily newspaper. Then the audience followed the performers to a different part of town; one evening on a Japanese bridge within the Smith College campus, another on nearby coal hills upon which belly dancers danced and another in a local gallery and performance space. In addition to the core-group of performers, each night I arranged for different local musicians, dancers, and other artists to join the rehearsal at five o'clock. On one day we incorporated horses into that evening's *Flash* and on another evening an exotic dance group and on another, a kite club.

I invited a few friends from New York City to join me in creating the parade and the *Flashes*. Kevin Kuhlke, who had recently participated in formative "paratheatrical" experiences in Poland with Jerzy Grotowski, arrived in Northampton to help out. In sync with the theme of the *Flashes*, Kevin proposed to offer a series of paratheatrical adventures that he called *Blazes* to the local core-group of performers. Each *Blaze* began at midnight and lasted until four or five in the morning and Kevin led us, often running, across rough terrain, through forests and into the streams surrounding Northampton. With the core-group performers, I participated in these highly rigorous, physically exhausting but exhilarating paratheatrical adventures. The nighttime trials were dissonant and demanding, but served to further cement the cohesiveness of our ensemble.

During the weeks of organizing the parade, staging the *Flashes* and participating in the *Blazes*, I did not sleep much. Pushed to my own limits by the contrasting circumstances and obstacles, I was challenged and aroused in ways that became exceedingly constructive to my development as a theater director. The *Flashes* taught me that with the proper preparation and a brain-trust of like-minded collaborators, an event could

be staged in less than three hours. While running through the woods in the middle of the night as part of Kevin's *Blazes*, I learned that I had far more endurance and physical stamina than I knew or imagined. Working to organize the big parade I learned about the art of arrangement and the importance of engagement with disparate and non-like-minded groups. All three undertakings instilled in me the necessity for patience, dogged perseverance, a positive attitude, and a deep trust that things will work out in the end. Perhaps trust in oneself and others is the key to one's relationship to dissonance, dissatisfaction, and things not working in rehearsal.

Adrian Hall

Perhaps I became a theater director thanks to the special brilliance of Adrian Hall, who was the founding Artistic Director of Trinity Repertory Theater in Providence, Rhode Island from 1964 until 1988. My first experience of professional theater happened in 1967 at Trinity Rep when I was fifteen years old as part of a groundbreaking program entitled Project Discovery, instituted with support from the newly founded National Endowment of the Arts. Thanks to this initiative, every school child in Rhode Island had the opportunity to travel to Providence to see theater by a world-class company. I arrived in a caravan of big yellow school buses from Middletown High School and my first experience of professional theater was Hall's production of Shakespeare's *Macbeth*. Afterwards, I felt altered and provoked. The experience of the production was for me both disturbing and stimulating; dissonant and resonant. I simply did not understand what was happening. Shakespeare's language was foreign to my ears and the way that the actors moved and interacted shook me to my core. Nothing was familiar and yet this combination of resonance and dissonance was electrifying. The experience roused me and gave me direction. I did not really understand what I had seen or heard but the experience

galvanized me; physically, mentally, and emotionally. My life would never be the same. I only knew that I had to follow the pulse of excitement triggered by this electrifying experience.

Twenty-two years later, in 1989, I was chosen to be the second Artistic Director of Trinity Rep. I looked forward with great anticipation to meeting Adrian Hall for the first time in person at the press event, a "changing of the guard," that he was to attend. When I saw Adrian, I immediately walked up to him to tell him what a huge influence he had had on my life. Much to my disappointment, he turned crisply away from me. Perhaps he was not happy that the Trinity Board had accepted his resignation and visibly he did not want to have anything to do with me. I lasted only one year at Trinity before the Trinity Board found a way to get rid of me. But for the entire exhilarating, frustrating, dissonant, and tense year there were reports in various newspaper articles about Adrian Hall's unhappiness with who I was and what I was doing to his theater. I was saddened by his lack of support.

Even after I left Trinity and moved on with my life, the stories of Adrian's denigrating comments about me kept popping up. Several years later, one of my Columbia University graduate directing students, who assisted him on a production of Shakespeare in the Park in Central Park, reported that he had approached Adrian, who was sitting in tech rehearsal with his long-term design collaborator, to implore, "Would you both stop saying negative things about my professor?"

More years passed and I was directing regularly at Actors' Theater of Louisville (ATL), which, thanks to the Artistic Director Jon Jory, had become a home away from home for SITI Company. Each year ATL hosts the Humana Festival of New American Plays and in 1998 I was invited to attend the Festival's "Big Weekend." People came from around the world to see full productions of brand-new plays during this crowded and festive weekend. One of the productions that year was a new play by Naomi Wallace entitled *The Trestle at Pope Lick Creek* and it had been directed by none other than Adrian Hall. On the Friday afternoon of the Big Weekend I climbed

the steps up to the smallish Victor Jory Theater to see his production. The theater was completely full except for an empty seat next to me. Waiting for the show to begin, I suddenly saw the tall, elegant Adrian Hall enter the theater and I knew in an instant that the seat next to me would be his. Had someone in the box office, knowing Adrian's enmity for me, done this on purpose? Or was this simple serendipity? Adrian filed past people in my row and sat down next to me. We both nodded "hello" politely and the play began.

What occurred next felt similar to what had happened to me as a fifteen-year-old seeing Hall's production of *Macbeth*. I was deeply stirred and moved by the production of this early work by Naomi Wallace; a young and not a perfect play. But, as the director, Adrian did not try to fix the play or alter it. He did not interfere with the usual director-tricks, rather, he allowed the play to breathe. Every moment had space, clarity, energy, and presence. As I watched, I found myself wishing that all of the graduate directing students at Columbia could experience this production to see how a director could work with a brand-new play by an untested playwright.

At the intermission I turned to Adrian and said, "Adrian, this is extraordinary, and I wish that all my students could see your production." Adrian smiled and during the second act we began to lean towards one another and by the end of the play we were holding hands. "Let's go to the bar and have a drink," said Adrian afterwards. We sat on tall barstools and talked and talked and for the remainder of the weekend we spent almost every waking moment together. We sat next to each other at the many festival productions. On the Saturday evening he invited me to dinner at Lillian's, a swank restaurant on Bardstown Road. We never spoke about Trinity. We never spoke about the past. We talked about theater and we talked about life. When the weekend was over, we said goodbye with great warmth. And that was the last time that I ever saw him. He went back to Texas and I returned to New York City. I will never know what Adrian Hall's own experience was during that weekend, but for me the memories linger, and I feel that

we came together in a way that moved our dissonance into the realm of resonance.

It is natural for humans to want to avoid difficult and challenging experiences that stir anger, fear, disappointment or anxiety. In my own life, I choose who I like and who I dislike, who I agree with and who I disagree with. I decide that I am the kind of person who does not like boats, or that I am afraid of falling, hard-boiled eggs, and enclosed spaces. And then, because of these decisions, I tend to avoid certain people, places, and things. And because of my hard-wired assumptions, when I do encounter these situations, I feel overwhelmed. As I get older, I find it increasingly tempting to take the route of comfort and certainty over any real discomfort. Experience has taught me how to circumvent the pain and embarrassment of vulnerability. And yet, I know that growth and in fact *life itself* is derived from states of fragility, discomfort, vulnerability and, yes, dissonance.

7

Ambiguity and Paradox

Power of Naming

Yes, I have tricks in my pocket; I have things up my sleeve.
But I am the opposite of a stage magician. He gives you
illusion that has the appearance of truth. I give you truth in
the pleasant disguise of illusion.

TENNESSEE WILLIAMS

As an undergraduate at Bard College in the early 1970s I
joined Via Theater, a group of like-minded theater majors
founded by fellow student Ossian Cameron. The company
started by investigating the work of the Polish theater director
Jerzy Grotowski, specifically around his seminal book *Towards
a Poor Theater*. After many months of grueling physical work,
five mornings a week in the basement of an old college dining
hall, Ossian surprised us with the proposal that we would
spend the summer months "taking theater to the people."

And so, very much in the ethos of the day, this is exactly
what we did. Seven of us and a dog named Godot climbed into
a chunky Ford van and traveled, first north into Canada, and
then across the United States to the west coast, camping out
and stopping to perform at every opportunity. Early on in our
nearly two-month journey we arrived in Montreal, climbed
out of our van and began a free-form improvisation in a nearby
park. People gathered to watch. It was going well until a man,

studying us quizzically, suddenly declared in a loud voice, "Oh, it's theater!" Satisfied that he had identified what had been bewildering him, he walked away, as did most of the remainder of our audience.

In the moment that the audience evaporated, I understood that the art experience requires the audience's participation in solving a slightly elusive mystery. Initially, it was probably curiosity that caused an audience to gather around us. As long as we maintained the attraction of a somewhat undefinable encounter, the audience was able to engage imaginatively in our offering. Through this experience, I learned that successful and resonant theatrical experiences do not preach truth but, rather, engage the audience in perceptual problem solving. It is they who are in pursuit of the truth and this search is, in itself, rewarding and is part of what produces the aesthetic experience. The audience is asked to use their imagination, to fill in the blanks, to complete the picture, and to hunt for meaning, which is, at best, implied rather than implicit. If the message is too obvious, the audience loses interest.

> In poetry, all facts and beliefs cease to be true or false and become interesting possibilities.
>
> W. H. AUDEN

On December 7, 2005, the playwright Harold Pinter, too ill to travel to Stockholm, accepted the Nobel Peace Prize from his wheelchair in London. The acceptance speech is worth listening to again or re-reading, especially in the light of our current cultural instability and political circumstances. Pinter spoke eloquently about the difference between truth and lies, reality and unreality in art versus in political life. He began by taking issue with himself when, in 1958, he wrote, "There are no hard distinctions between what is real and what is unreal, nor between what is true and what is false. A thing is not necessarily either true or false; it can be both true and false."

The Nobel Prize was awarded soon after the revelations of torture of Iraqi prisoners at Abu Ghraib. Pinter had condemned

the invasion of Iraq and Afghanistan led by George W. Bush and felt that the truth must be excavated and drawn out into the pale light of day. He affirmed that, as an artist and within the realm of art, he still stood by his assertions of 1958, but as a citizen he emphatically could not defend that statement. He continued, "As a citizen I must ask: What is true? What is false?"

To tell the truth *as a citizen* is to name things for what they are. Calling things by their true names can cut through lies that obfuscate the multifarious crimes that happen around us every day. To name something with clarity and force initiates the process of laying bear the truth and ultimately leads towards liberation from oppression. In her book *Call Them by Their True Names*, Rebecca Solnit wrote, "The key to the work of changing the world is changing the story, the names, and inventing or popularizing new names and terms and phrases." Naming correctly can serve as both a diagnosis and an analysis of a nebulous but troubling predicament.

The power of naming is evident in the terms of Black Lives Matter and #MeToo, which address issues around racial inequality and injustice, and around sexual abuse and violence. Other movements are afoot that tackle problems of workplace mistreatment and domestic violence perpetrated by the assumptions of a patriarchal and racist culture. Naming the shadowy deeds of politicians and powerbrokers can lead to their ousting. Naming and renaming can build communities and generate collective action.

Making resonant art, on the other hand, is a different kind of enterprise. Rather than stating the truth directly, successful art, through contradiction, juxtaposition, and paradox, can produce a *sense* of truth. This *sense* of truth is different from straight-up facts or naming. Picasso famously said, "Art is the lie that enables us to realize the truth." In the realm of art, truth is often found in paradox. Setting up oppositions and radical juxtapositions helps to create enough space for the *sense* of truth to emerge within the viewer, listener or audience.

Sense of Truth

The *sense* of truth evoked by art can function somewhat like a Zen *koan*. In Zen Buddhist practice, a koan is a story or dialogue that provokes "the great doubt" via a paradoxical anecdote or riddle without a solution and is meant to stop the mind mid-stride and demonstrate the inadequacy of logical reasoning. Described as a mental explosion that leads one to abandon reason, a koan is a double bind that turns you away from the vice grip of logic. A koan demonstrates how paradox can induce the *sense* of truth and according to Zen practitioners, the experience of a koan can reveal greater truths and even provoke enlightenment. This moment of truth, according to Zen, is evoked by *experience* rather than by description.

The process of artmaking, despite its liberal use of illusion and allusion, compression and pastiche, is most emphatically a search for a sense of the truth. Resonant art, much like a koan, sets up the circumstances for an experience or sensation of truth. And this search for a sense of the truth is the point of the activity. The substance of life is taken apart, the materials are distilled, and the outcome is an amalgam, a series of juxtapositions. Paradoxically, a closer proximity to truth can be evoked though melodies, fiction, and pictorial representations than in a direct representation of reality. Art can more successfully communicate what is inexpressible than any other medium and can help us to understand one another, thereby bringing us closer to other communities. The power in art lies in its unique ability to produce identification and empathy through the experience of these paradoxes and juxtapositions. The philosopher Slavoj Zizek wrote, "An enemy is someone whose story you have not heard." Empathy is the first step towards the mitigation of social, familial, and political clashes. An audience experiencing the story of someone heretofore unheard can be a powerful trigger for change.

The philosopher and gender theorist Judith Butler, speaking at a lecture on Euripides' *The Bacchae*, proposed that Greek plays continue to be indispensable because our family relations

are so complex and befuddling, that a dramatic form is required for us to be able to realize our own situation with clarity. Art evokes the truth through artifice and is capable of examining issues that are perhaps too convoluted and confusing to tackle straightforwardly in daily life. And the theater in particular is uniquely capable of engaging the complexities of family issues through iconic stories and myths. Within the language of theater, the puzzling and troubling aspects of kinship are scrutinized through enactments of taboo, murder, and incest. Frightening uncertainties are exposed and ultimately the experience can trigger identification, recognition, and resonance within the audience. Butler suggests that one of the political results of these dramatic narratives is the shared realization that laws are necessary to handle the chaos of our lives.

Sermonizing is the least effective technique in all of the arts because, in general, audiences do not want to be lectured to or talked down to. Without the poetry of art, there is no space to breathe. Consider the difference between reading a newspaper article and reading a poem. The experience and the methodology of news reporting and poetry are completely different, both for the writer and the reader. In the case of a newspaper article, we search for facts. Within the spaciousness of a poem, we engage in an imaginative journey that the writing only suggests through metaphor.

In the theater, truth is delivered through metaphor, which carries or transfers the sense or aspects of one thing into another. Imagine metaphor as a bus that transports meaning. In modern Greek the word for bus is *leoforio*. Note the root *foreio*, which is where we derive the words and concepts of meta*phor* and sema*phore*. *Phore* is a form that carries or bears something. Imagine a bus as the theatrical form, the container for meaning and paradox. Then, by means of metaphor, the audience puts the pieces together using their imaginations. A theatrical space is created in which ideas can do battle with one another. The theater requires the audience to bring a receptivity to paradox and opposition and to play an active role in the adventure.

The Ambiguous Smile

The poorest way to face life is to face it with a sneer.

THEODORE ROOSEVELT

In ancient Greece, the actor playing Dionysus, the Greek god of theater, in Euripides' *Bacchae*, wore a mask featuring a fixed smile. This smile is an enigma and, to me, a disturbing but fascinating one. In mask form, the smile remains stable throughout the play. It is the audience's reaction to the static smile that alters over time. In the play, the god Dionysus and his band of Bacchants arrive from Asia Minor to Thebes with a vital message: Do not put up walls between yourself and the rest of the world. Let go. Nothing is certain. Nothing is solid. The mask of Dionysus, in that fixed smile, is one of the play's central features. But by the end, the multiple acts of violence would have transformed the mask's smile into the appearance of a divine sneer or a ghoulish expression of inappropriate cheerfulness at a revenge so easily executed. But, in fact, the mask has not changed, rather, it is the audience that has altered the way that they see the mask.

Preparing to direct *The Bacchae* with SITI Company at the Getty Villa in Los Angeles in 2018, I wondered how to embody Dionysus' smile. I have never cared for masks and I did not want to use any in our production. While intellectually I understand why a mask can be liberating both for actors and audience, I love the human face, with all its variations and nuance, and for that reason I resist asking actors to put on masks. And yet, throughout the play, Euripides often refers to the smile.

The Greek scholar Helen Foley proposed that "the visual effect of the smiling mask has the same doubleness as the language of the play itself." The smile, both ambiguous and inscrutable, seems to embody ambiguity and binary opposites. It radiates what at first seems to be a relaxed harmony and later it is revealed to conceal frightening and unfathomable depths; at first the smile of a martyr and later the smile of a destroyer. The action of the play shows the god's divinity

indirectly and symbolically and suggests that we cannot adequately see Dionysus with human eyes. The mask as well as the narrative, contains ambiguity and multiple meanings: benevolence and destruction, truth and deception, delight and anger. My task, in directing *The Bacchae*, was to create the space for these multiple meanings and the inherent ambiguity of Dionysus, without using a mask.

The *Mona Lisa* smile has a similar mystique and radiates an ambiguous dichotomy between blissful and melancholic. Leonardo da Vinci worked on the Gioconda portrait for nearly eight years. Right up to his death, he claimed that he had still not quite caught that enigmatic smile that he was seeking. Some said he had fallen in love with his sitter. The artist Giorgio Vasari, a near contemporary of da Vinci, said that the portrait was "more divine than human." The magic of the *Mona Lisa*'s smile is that she seems to react to the gaze of the observer, who wonders what she is thinking. She smiles back mysteriously. The experience of the painting is uncanny. Is the ambiguity purposeful? Is she mocking the viewer or is there sadness in her smile? And the smile, which never changes, seems to linger as the visitor moves away. We infuse the smile with what we want to see, and then we carry it with us.

Da Vinci invented a method of painting that the Italians call *sfumato*, which is a blurred outline and mellowed colors that allow one form to merge with another and that leaves something to the imagination. The *Mona Lisa*'s expression remains elusive.

> Art is supposed to have multiple meanings. . . . The more a single meaning dominates a work, the less it is a work of art. Something that has one and only one meaning—no matter how interesting or important that meaning is—is no longer a work of art.
>
> COLIN MARTINDALE

The beauty that I find in actors' faces does not emanate from visible strain or from "putting on a face." This beauty originates

in what director Tadashi Suzuki calls "the good face." Despite
the stress of the extreme physical and emotional act of being
onstage, when an actor truly relaxes her face and allows the
genuine feeling of engagement to be present in the body, a
gentle smile tends to appear. The choreographer Pina Bausch's
dancers always seem to be smiling slightly. Are they enjoying
some private secret? I find their presence enormously attractive
and I am drawn towards the purposeful ambiguity of their
visages.

The image of the Buddha sitting silently under a tree, with
his eyes half-closed is one of the most iconic images in the
world and one of the most reproduced. The smile on his face
radiates beauty, kindness, and understanding. It also emanates
power and equanimity. Why is the Buddha smiling? What is he
smiling about and to what purpose? Can I smile like that too?

Ambiguity

In considering the phenomenon of the smile, I am confronted
with my own history of *not* smiling. As a child, I disliked being
asked to smile. The more I was told to smile, the more I resented
the intrusion and I made sure that my face remained glum. But
my inner story, my feelings, were quite different to what showed
on the outside. The more joyful I felt, the less I was able to
reflect that joy in my own body. To this day, when I am fully
engaged watching a play or in a rehearsal, the less I move. In my
teens and twenties, well-meaning friends, knowing how devoted
I was to the theater, invariably gave me tragedy-comedy mask
pins and tee shirts for my birthday or as Christmas presents. To
me this symbol, with its smiling face and frowning face, always
seemed to be such an embarrassing cliché, and I could never
bring myself to wear them. But perhaps embedded within these
two adjacent faces lurks a valuable lesson about the potential
richness of emotion and the purposefulness of ambiguity. In
ancient Greece, the two shapes were paired together to show
the two extremes of the human psyche.

The Greek word *klausigelos* means a prolonged sequence where laughter and crying are interchangeable. Perhaps the tragedy-comedy mask embodies the idea of extreme and *mixed* emotions. In modern Greek culture, *klausigelos* is still understood as a complex but emotionally rich state, laughing through tears, or weeping through laughter. The Buddha's equanimity is itself an emotion. Paradoxically, the smile is synonymous with having come face to face with suffering and overcoming it. The smile lies at the midpoint between pleasure and pain, midway between liking and not liking, wanting and not wanting, greed and hatred. It points to an intensity of emotional response that accepts and even celebrates what is happening without trying to distort it.

Seeking Uncertainty

The experience of complexity, novelty, uncertainty, and conflict, which are the essential properties of art, can tug at deep emotions and prohibit any sense of closure. In our day-to-day lives, we generally do our best to avoid uncertainty. But a number of recent psychological research studies found that in certain circumstances, including theater, sports, visual art, and suspense novels, people seek out the thrill of ambiguity. In fact, removing uncertainty from those activities seems to reduce an audience's enjoyment.

The biologist and neuroscientist Nikos Logothetis, who specializes in visual perception and object recognition, showed that the resolution of ambiguity is an essential part of the task of consciousness. In this sense, even though the experience can generate emotions of uncertainty and even anxiety about interpretation, ambiguity is central to any resonant artistic experience. Audiences gravitate towards art that is slightly baffling, finding these works more attractive and engaging than art that is didactic.

8

Energy and Restraint

Energy

A great theater must have an open door through which life
flows like a stream.

ELIA KAZAN

The human body contains enormous quantities of energy. In
fact, the average adult has as much energy stored in fat as a
one-ton battery. This energy exists in the form of heat amassed
in the body and it fuels our everyday activities. Movement
produces kinetic energy, which can be converted into power
and action in the world. But this heat can also be easily wasted,
and it can dissipate and diffuse rather than collect and
concentrate. Wasted and dissipated energy brings about
entropy. As I grow older, I am increasingly aware of the need
to shepherd available energy and employ it effectively. Is it
possible to concentrate and magnify one's energy and use it
efficiently both in life and upon the stage? The answer, it turns
out, is *yes*!

"Energy at its highest level!" exclaimed John Cage. "Energy
that can be expressed by the movement of the human body,
will not burst forth unless the dancers have had the courage to
train themselves with extreme meticulousness." Cage, who was
known for his delight in the unplanned and the unexpected,

nevertheless recognized the necessity for an artist's rigorous preparation and training.

When I was in my early twenties, I loved taking dance classes. I was a terrible dancer, but I enjoyed the challenge of the moves and the steps that were always just beyond my reach. After graduating from college, I moved to New York City and regularly attended classes at the Merce Cunningham studio and the Eric Hawkins studio. I also studied with Elaine Summers and I signed up for a six-week intensive at the Alwin Nikolais/Murray Lewis dance studio just north of Union Square. The Nikolais/Lewis space was vast, and as I remember it, the width of a city block. I trained every day with, from my point of view, a hundred anorexic dancers. One day, as I was throwing myself across the floor in various combinations with all of the other dancers, Alwin Nikolais himself entered the studio. By this time in the mid-1970s, he was getting older and not teaching very much personally. He surveyed the class and suddenly called everyone to a halt. Nikolais pointed directly at me and spoke in a loud voice, "See her? She can't dance, but she can move!" I was humiliated. It took me years to realize that he was actually giving me a compliment. He recognized the energy that I was putting into the movement.

Part of the reason that I am a theater director is that I love watching gifted performers accomplishing feats that I can only dream of doing personally. At the time of Alwin Nikolais's comment, I enjoyed moving with lots of exuberance and energy, but I lacked the necessary physicality, talent, and technique to really be a dancer.

Acting is a sport. On stage you must be ready to move like a tennis player on his toes. Your concentration must be keen, your reflexes sharp; your body and mind are in top gear, the chase is on. Acting is energy. In the theater people pay to see energy.

CLIVE SWIFT

Questions concerning the successful deployment of human energy are not only pertinent to the realm of theater, but they are also applicable to one's day-to-day functioning. I notice, for example, that early in the day I am full of energy and willpower, with an appetite for work, but as the hours pass, I lose the inspiration and will. I run out of steam.

There is an ongoing debate in the psychological research community about the relationship between stress and ego depletion in relation to willpower, which, in turn, reflects energy levels in the body. On any given day, there exists only a finite amount of fuel that allows us to focus and that provides us with the mental energy to tackle the challenges that face us. Some of the daily activities that can sap the fuel include making decisions, weighing options, and exercising self-control. During his tenure as president, Barack Obama wore the same style blue suit each day because, he noted, it cut down on his amount of his decision-making. He simply did not have to think about what he would wear each day, and this literally left him more energy for other decisions.

T'ai Chi

The Chinese martial art T'ai Chi Chuan has consistently provided me with opportunities to explore the myriad qualities of energy. During the forty years that I have practiced, I also studied aikido and yoga, but I always return to T'ai Chi, which, for me, is my foundation. Over the years, and thanks to the wisdom of this ancient form and an ever-deepening study, I am brought gradually closer to a physical understanding of differing qualities of energy.

Through T'ai Chi Chuan, I discovered that Taoism and the Chinese internal martial arts distinguish between three essential energies that sustain human life: *Qi*, *Jing*, and *Shen*. These three cornerstones are known in Taoism as the "Three Treasures" and in Buddhism as the "Three Jewels." I have found these three aspects of energy useful in exploring my own

vitality as well as considering an actor's approach to training. With sensitivity to these three essential energies, the body can be trained to use energy more efficiently.

Qi is breath energy. *Jing* means an essence. *Shen* is a divine or human spirit. Imagine a candle. The *Jing* is the wax and wick, the *Qi* is the flame, and the *Shen* is the radiance given off by the candle. *Qi* is the invisible life force that we are all born with. It comes and goes in intensity depending upon one's physical, mental, and emotional state. *Jing* is the material in the body that governs the body's growth and development and it is gradually burned up as the body ages. The loss of *Jing* is hastened by stress, overwork, illness, poor nutrition, pollution, and substance abuse. *Shen*, equated with spirit or mind, is a manifestation of the higher nature of a human being and it is expressed as wisdom, compassion, generosity, and tolerance.

Unlike *Jing* and *Qi*, one is not automatically endowed with *Shen*; rather one can achieve an augmented *Shen* through self-control, training, and mindfulness. *Shen* can also be developed by means of physical disciplines such martial arts, dance and music, and other creative activities. Apparently, the *Shen* can be perceived in the eyes, which is classically seen as mirror the soul.

As I grow older, my muscles lose strength quicker. However, if I can learn to concentrate my mind properly, *Qi* can be generated in the area that used to require muscle strength. The muscles may not be at the same levels as when I was younger, but *Qi* can replace brute strength. This transition requires a deep relaxation of the muscles that in turn allow the blood flow to intensify. *Shen* exists upon the foundation of a strong *Qi* and a sound *Jing*.

Despite my interest in and study of the varieties of human energy, I still struggle on a daily basis. Mismanagement of energy often leads me to lethargy and collapse. Sometimes I exert copious amounts of energy in directions that do not ultimately pan out. Projects do fall apart. Friendships do disintegrate. The body weakens. And yet, thanks to the regular practice of T'ai Chi Chuan and my ongoing engagements in

rehearsal, I have learned to value rather than avoid the inevitable obstacles that arise daily. I have come to accept that wrestling with obstacles is what ultimately increases energy and if I want the benefits, I also have to accept the physical and emotional costs of engagement. In the end, it is the struggle rather than the rewards that matter.

> Anger is addictive. The brain likes it. It likes those chemicals. And we are becoming a nation of addicts. And who are the dealers? Beware when you feel anger coming from any direction. Not that we have no reason to be angry, of course we have many reasons to be angry. But the solution to problems comes from a calm mind. That's the best way to do it. Remember, practice kindness.
>
> PAUL SIMON

In addition to the solo form, the study of T'ai Chi Chuan includes a practice known as "push hands," which improves one's ability to maintain balance while under attack. Push hands is a two-person training that could be considered a kind of sparring, but in fact the practice is a deceptively complex expression of holding one's seat. In addition to timing and coordination, training with a partner allows one to develop *ting jing* (listening power), the sensitivity to feel the direction and strength of an opponent's defense. The practice undoes the natural instinct to resist force with force, developing the ability to respond without creating resistance, to yield to force and redirect it. While maintaining my balance, I sense and redirect my sparing partner's center of gravity and exploit it.

Energy in Rehearsal

My colleague Leon Ingulsrud pointed out that in the United States we often speak glowingly about the quality of an actor's energy in performance, but we rarely speak of an actor's energy in rehearsal. Leon laments this situation and then proceeds to

dissect the materiality of energy, emphasizing the fact that energy is not an abstract notion, but rather "fundamentally and specifically physical."

What are the components of human energy and what training can activate energy successfully? How do actors develop the energy required to communicate articulately, physically and vocally, to other actors and to the audience? Does an audience return the energy that actors give them? Why is energy not a subject of constant attention in rehearsal? These questions require a more fundamental one: What is a rehearsal for? Is rehearsal an activity in which one stages a text or, alternatively, is rehearsal a time and space to identify and stimulate the energy required to meet an audience? Or both?

Perhaps our lack of sensitivity to qualities of energy in rehearsal in the United States arose around the same time that Lee Strasberg, inspired by the early innovations of Konstantin Stanislavsky, began to experiment with affective memory in the early 1930s. Due to the success of these experiments in the realm of film and television, theater actors gradually shifted their attention from the physical and emotional feat of encountering an audience to an increasingly internal focus in order to tap into rich emotions via personal memories. Unfortunately, Strasberg grasped prematurely onto a very narrow fragment of Stanislavsky's overall legacy and missed out on the breadth of his innovations around acting and training.

For the nearly thirty years of SITI Company's existence, I have watched the actors train before every rehearsal and performance, generally beginning with the Suzuki Method of Actor Training and then proceeding to an open Viewpoints improvisation that most often pertains to the play we are rehearsing. Watching, for me, is always valuable and the experience is physical for me as well as it is for them. If I am paying attention sufficiently, the actors breathing alters my own. Through watching, I grow increasingly sensitized to the actors' inclinations and to their instinctual moment-to-

moment decision-making. Through their training, the actors channel palpable energy into the rehearsal hall or onto the stage.

Restraint

An artist develops a combination of ample enthusiasm and intentional restraint. Without passion, energy, and excitement, the results of their efforts will be weak and will lack resonance. But passion must be intentionally counterbalanced with restraint, which is developed through technique. Without self-restraint, expression becomes all energy, unmitigated by thoughtful response. Self-restraint is a technique to temper the excitement and to fashion meaningful expression. Without conscious moderation and precise technique, artistic expression can appear chaotic and difficult for an audience to grasp.

Learning technique, cultivating the potent combination of exuberance and restraint, while practicing patience and perseverance demands a deep commitment to the ongoing human dialogue. We long for authentic exchange because we desire an encounter with the best parts of other people and ourselves. We want to be seen, heard, and appreciated by others and we can help one another in the quest for truth and subtlety. And yet, in our current cultural and political moment of rupture and uncertainty, one of the chief goals or strategies within arguments in the public arena has become to invalidate one's opponent's own story. This rhetorical tactic is meant to break the adversary down. Instead of engaging other people's arguments on their own terms, the intention is to locate and exploit character flaws, eliminating the option and benefits of a straightforward conversation.

To take the example into the realm of physicality, you push me and then I push you back. If I do not intentionally restrain myself, I will naturally push you harder than you pushed me. If then you push me back, without intentionally restraining yourself, your push will be more forceful than mine. Without

deliberate modulation, the escalation will continue. To speak scientifically, if the "top down" control system in the prefrontal cortex of my brain fails to modulate my actions, especially if there is an anger-provoking stimulus like a push, violence ensues. These reactions are chemical, and they are natural.

It is easier to break things than to fix them and rage can be dangerously satisfying and also treacherously entertaining. But an undisciplined brain is a malfunctioning brain. It is never too late to develop and train the mind in order to find attunement and coherence with one's surroundings. Civilization is restraint. The way to discipline the brain is to learn to balance exuberance with restraint and conscious delay. Wait. Listen. Waiting and listening are genuine and constructive actions. Perhaps our job on this earth is to mend incoherence by listening accurately. Having the discipline required to drop one's own nagging worries and truly listen to another person is a positive act in the world, an act of respect and trust.

Maybe learning to engage in real conversation is the necessary corrective to careening clashes and the escalation of violence. The art of a good conversation requires leaps of logic, respect and the recognition that the other person has a valid position. We learn to take turns talking. If we look for what is valued by the other person, we may find out what we value ourselves.

Hold Your Seat

Making art requires energy, skill, experience, and effort. But it also entails patience and listening and, perhaps most importantly, the ability *to hold your seat*, which means staying put and not running away. Maintaining physical and mental attention over time is the key ingredient in the path to resonance. Holding your seat means not letting events hijack emotions and not throwing in the towel when things get uncomfortable. It means neither repressing your feelings nor responding reactively and requires the discipline to not be

distracted, to trust in the process, and to cultivate enough patience and restraint for the alchemy of innovation to occur.

During much of my adolescence and throughout my teen years, I was passionate about horses. My Navy family accepted my obsession and allowed me to attend horse camp every summer until I was fourteen years old. At fifteen, I was hired to teach riding and I rode professionally for various stables, sometimes competing in judged exhibitions at horse shows. I also had the opportunity to train, or "break," one of the stable's two-year-old horses. Two years is the age at which most horses are ready to hold a bit, carry a saddle, and learn to be ridden. Breaking a colt is not an easy process for horse or rider. The horse is skittish, and the rider must exercise tremendous patience and firmness and, all the while, hold her seat.

In riding, holding your seat is imperative. The successful rider creates an envelope, a physical connection with the horse's body and mind, sensing how to relax and follow, allowing the body to harmonize with the horse's movement so as not to create a feeling of separation or opposition. The goal is not to impose control over the horse but rather to create empathy, clear communication, and compassion rolled into one. The rider figures out how to influence the horse without interfering with the horse's body and will. Eventually, in training these young horses, I learned to relax and to allow my mind and body to harmonize with the horse so as not to block its own sense of agency.

Ultimately, I gave up riding horses to become a theater director, a profession that, due to the nature of the engagement of rehearsal, also requires me to hold my seat as well as to concentrate in bigger chunks than I do in my daily life. I wonder if, without the discipline of theater making, I would simply flit around, an aimless butterfly, alighting and taking off, alighting and taking off again, never satisfied, never settled. But by the nature of the sustained engagement and the necessity for conscious delay in a rehearsal, I cannot run away. I am required to linger longer. The playwright Chuck Mee proposed that a theater director is the person who can endure what is intolerable

longer than anyone else. These days, one of the biggest challenges for me is the physical toll of the hyper-mediated environment. Spreading my focus too widely, whether on social media or drifting around the internet or the temptation of pushing the Amazon buy-now button, is an expression of not holding my seat. In a world of constant distraction, exhaustion can set in and that exhaustion also starts to feel normal. This fatigue is the cost of not holding your seat. Spreading your focus too thinly, overloading your attention over long periods of time and misspending the precious commodity called energy, in the end, just makes you tired and truly disengaged.

One evening in Santa Monica, California I saw Bo Burnham's film *Eighth Grade*. I walked out of the cinema in a daze and remained haunted by it for long afterwards. In the film, a young girl struggles to get along with her peers. She and her friends are glued to their phones and seemingly addicted to social media. She is desperate to be accepted and, although isolated in her personal life and at school, she sends out messages of optimism and motivation to the world via her vlogs and Instagram.

Every once in a while, I encounter a work of art that feels so true to our current cultural moment that I become somewhat catatonic after the experience. *Eighth Grade* had that impact upon me because it captured the culture of flighty digital dependency that I recognize as the baseline, the underbelly, of our current daily lives. The ramifications of the digital age are slippery. The generation portrayed in *Eighth Grade* was raised from birth on electronic devices, receiving an in-depth intensive training in distraction. But constant diversion is not only the realm of thirteen-year-olds. I too am vulnerable. It is so easy for me to slide down the all too pervasive slopes of technology into a well of constant distraction and endless desperation for diversion and instant gratification. It seems that when I am online, I am neither present in the space that my body occupies nor am I fully engaged with what I am looking at or listening to. Where am I then? Who am I there?

Flitting around from one site to the next, we are in danger of becoming unfocused and flighty. We are unable to

concentrate over an unbroken period of time or even sustain emotional engagement. The art of holding one's seat is an increasingly critical skill because, ultimately, we become what we pay attention to. Perhaps this is the moment to shift our attention to faith, energy, and restraint.

Faith

One who could make of himself a vacuum into which others might freely enter would become master of all situations.

OKAKURA KAKUZO

I probably share with many others a terror and trepidation around the process of embarking upon a new endeavor. I am often frightened and apprehensive of an upcoming rehearsal or a difficult encounter. My stomach churns in a chaotic mess and I begin to feel fearful. Thankfully there is a saving grace that keeps me from turning away and running, and that grace is the image of my shoes. Literally. I look down and see my feet and my shoes walking, one step after the next, towards the rehearsal or towards the difficult encounter. The fuel that makes this dreadful walk possible is faith. I strive to cultivate the faith that something positive will occur once I arrive at my destination. And the good news is that it usually does.

Faith is not necessarily a religious dogma, but rather an inner resource available to each of us. And faith is a central ingredient in the creative process. Faith allows me to be present despite my anxieties, so that I can move forward rather than be lost in resignation or despair in relation to the challenges facing me. The word faith is easy to say or write, but immensely demanding to embody. Naturally I want control over the circumstances and over the creative process. And I want to make action happen. But ultimately, after adequate preparation, there is nothing to invent, there are only elements to edit. The practice of faith requires that I calculate less and feel more. In rehearsal I must be willing to let go of my preconceived

ideas. I must walk into the center of the maelstrom, listen closely, lean in, and trust that events will organize themselves around me.

And yet, the theater is also only as good as its execution. Good execution requires my sweat, innate stubbornness, and a demanding nature. It requires discernment and preparation. And therein lies the paradox: all of the preparation, groundwork, and honesty at critical moments matter tremendously but ultimately, I must also have faith that with patience and attentiveness, the process will yield fruit.

I prepare for these acts of faith carefully by establishing the groundwork and by paying close attention to the details. My preparation starts with the arrangement of the circumstances. At first, I choose a subject matter that resonates sufficiently with me. Then I engage in a rigorous process of study and research. I select the best collaborators imaginable and I take good care of the conditions of the rehearsal hall and the specifics of the performance venue and the audience. Then, my job is to make sure that everyone is telling the same story. Once all of this preparation is done, faith in the process itself becomes imperative.

Faith is not about the outcome; rather it encompasses a willingness to make space for change and to be willing to let go of all favorite bits in the process. Faith does not require an abandonment of reason, but it does imply that belief, confidence and trust is possible despite the absence of proof because at, critical moments in the creative process, proof is simply not possible or desirable.

In leaving something unsaid the beholder is given a chance to complete the idea and thus a great masterpiece irresistibly rivets your attention until you seem to become actually a part of it. A vacuum is there for you to enter and fill up to the full measure of your aesthetic emotion.

OKAKURA KAKUZO

Seeking the Vacuum

One way to cultivate faith is to look for the vacuum rather than the volume. Okakura Kakuzo, in his insightful and influential *The Book of Tea*, proposes that one starts seeking the vacuum by looking for empty space and empty time, also known in the visual art as negative space. He writes, "A vacuum is there for you to enter and fill up the full measure of your aesthetic emotion." A vase is the space made for its contents and it also highlights the empty spaces around it. My faith in the collaborators creates the space for them to contribute. But then, how can I exercise that faith without losing the condition of the room? How is it possible to create a vacuum into which others may enter and function freely and yet in which I am still able to remain present?

In the theater we attempt to create enough space, enough of a vacuum, for an audience to join us. We must provide them with sufficient space to participate imaginatively. If we can create a vacuum in which others may join us, we will have achieved something profound. Only in a vacuum does motion become possible.

Faith is not something that I *have* any more than a vacuum is anything that I can retain. Faith is an action. A vacuum is available at any moment; I simply have to become aware of it. To work in the presence of faith I must be willing to embark upon a journey with no guarantees of the outcome. I must cultivate the courage and sufficient faith to step into the unknown and to meet whatever the next moment brings.

As in the context of a great conversation, to develop faith in a partnership or in a collaboration, it is necessary to accept the others' biases as characteristics rather than problems to fight against. Using the analogy of a traditional musical instrument, good musicians learn to work within the range of pitch, dynamics, and polyphony of their instrument as they develop their expressive capabilities with it.

9

The Present Moment

The Privileged Moment

With her foot on the threshold, she waited a moment longer
in a scene which was vanishing even as she looked, and
then, as she moved and took Minta's arm and left the room,
it changed, it shaped itself differently; it had become, she
knew, giving one last look at it over her shoulder, already
the past.

VIRGINIA WOOLF, *To the Lighthouse*

Harold Bloom called the effect of Virginia Woolf's writing
upon the reader as "the ecstasy of the privileged moment."
What an apt trope to describe the most resonant moments in
art and in life. Woolf titled her only book of autobiographical
writings *Moments of Being*. Art, and in particular theater, is
uniquely qualified to create ecstatic "moments of being" by
altering one's experience of time and space and creating the
possibility for profound moments of resonance.

One's perception of time is generally subjective and alters in
relation to one's inner state, emotions, and moods. For
example, I make everyday decisions such as whether to take
the elevator or the stairs based on an anticipation of duration
linked to my current feeling about time passing. I notice that
time seems to speed up when I am enjoying myself and then it
slows down again during periods of what might be considered

boredom. But the notion of boredom may be misleading. By being in the present moment, attentive to the surroundings and to other people, I create the circumstances for a deeper penetration of time, and I am more likely to notice the opportunities that arise in these moments of being.

Bloom's term "the privileged moment" suggests special moments of being where the mind opens to what it could not normally perceive. It has also been used by, among others, the filmmaker François Truffaut and, perhaps most frequently, by the writer Marcel Proust. Scholars agree that these "privileged" moments are extremely intense and of short duration, that they destroy the rules of time and space and that they are ephemeral and potentially transformative. For Truffaut, they are the ones that linger in the viewer's memory. The Proust scholar Bettina Knapp wrote about the Narrator in *In Search of Lost Time*, "such privileged moments were triggered by his senses: taste, sight, smell, feeling, hearing." The activation of memory can create a continuous present even while referring to the past.

Vertical Time

Usually we think of time as a sequence of events that happened in the past or that we want to happen in the future. And yet, this is only one version of time—*horizontal time*. Art, on the other hand, creates the experience of *vertical time* for the perceiver by plunging a stake or dropping an anchor into the endless flow of time, thereby creating a sense of eternity in the human body. A Van Gogh landscape painting offers a taste of eternity by allowing us, in its proximity, to experience vertical time. Vertical time arrives in small doses and has no past and no future outside of the present moment. In vertical time, *nowness* is absolutely real and non-divisible. Experiencing vertical time, I am more awake, more present; I sense more, and I see more. Intervals of time feel longer when I pay close attention to the present moment and allow for the array of

differentiated perceptions that are within my reach. I notice the mist rising off of a meadow. I taste each sip in a cup of fragrant afternoon tea. I can fully enjoy an aimless walk at sunset. Music theorist Jonathan Kramer describes vertical time in music as "A single present stretched out into enormous duration, a potentially infinite 'now' that nonetheless feels like an instant." In the experience of a musical performance, it is possible to arrive at the sensation that there is no differentiation between past, present, and future. The experience of vertical time resets and refreshes us.

The theater too has the capacity to create privileged moments by setting the conditions for an audience's experience of vertical time. The theater shares with music the languages of time via tempo, duration, rhythm etc., but it also embraces the semantics of space, encompassing architecture, shape, and spatial relationship. Within the languages of time and of space, how do we create the conditions of a resonant experience for the audience? How do we develop the ability to embody vertical time, to stop, to put on the brakes and bring the audience with us into our present moment?

If we obliterate the future and the past, the present moment stands in empty space, outside life and its chronology, outside time and independent of it (this is why it can be likened to eternity, which too is the negation of time).

MILAN KUNDERA

Bill Driver

As a midyear undergraduate transfer student at Bard College in 1972, I stood on a long line to sign up for a popular theater class taught by the chair of the theater department, Bill Driver, who would soon become my first directing teacher. Sitting quietly at a small desk, Driver seemed to ignore the frantic atmosphere of impatient students vying for placement in

various classes. After what felt like an interminable wait, I finally stood before him, surprised to find him relaxed and present with me, interested in who I was and where I came from. Despite the surrounding chaos, he seemed neither rushed nor harried. He paid no attention to the roiling line of irritated students behind me. This demonstration of patience, and his attitude of paying attention to one-thing-at-a-time, became my first lesson in directing from Bill Driver.

Human life spans a relatively short and unpredictable arc of time and the nagging question of how to handle the day-to-day encounters and trials can be challenging. We are born worriers and I am no exception. Without tempering my natural proclivity to hurry, I tend to rush around trying to make things happen and to fill the gaps with activity and distraction. I agonize constantly about how well I am doing in comparison to others and I fret about what I am missing out on. But with vigilance and restraint in my relation to time, I have learned that I can occasionally temper these tendencies.

In his quiet and understated way, Bill Driver turned out to be a great teacher. I was particularly excited to enroll in his directing class because, even though I had been directing plays since I was a teenager, I was never really conscious of what I was doing. I arrived early for the first day of class and sat expectantly, with my pen poised, ready to take notes about how to direct. Driver arrived a little late, holding a cigarette in one hand and a cup of coffee in the other. "It is impossible to teach directing," he said to the six of us in his distinctive English accent, "therefore we shall begin with Ibsen's *Peer Gynt*. I have divided the play into six parts, and each of you will direct one." And that was it. End of the directing class.

Although Bill Driver was supportive and always had time for me, I learned about directing from him mostly by watching him direct plays with students. I watched how he constructed captivating theatrical worlds by weaving design, music, and language into a compelling whole. I continued to be impressed by how calm he remained amidst the constant tumult that surrounded him. He directed an elaborate production of John

Webster's Jacobean play *The Duchess of Malfi* where each of
the main characters had a doppelgänger who echoed some
of the text and wore a bulky fiberglass costume that could
stand up on its own. Bill Driver's elaborate dramaturgical
interventions somehow managed to amplify the inherent
meanings of the play.

It was not until my senior project, a devised play that I
directed using bits and pieces from the many works of Eugene
Ionesco, that Driver's teaching truly kicked in. He arrived at
my technical rehearsal one afternoon and stayed for about five
minutes. Before leaving, he said to me, "Please come to see me
in my apartment when you are finished." I arrived at his home
at about 11:30 that night and he opened the door and handed
me a glass of scotch. We sat down together, and he proceeded
to share his observations about my directing. The acuity and
seriousness of his comments about what he had witnessed
during those five minutes of rehearsal are issues that I am still
working on as a director to this day. He pointed out that I take
too long to make a decision. I cannot remember the exact
words of his other notes, but essentially, he told me to trust
myself and my impulses more than I do. When he came into
the technical rehearsal, he did not have to stay long, but simply
by being present and attentive, he was able to glean a great
deal of information in a short time and then share it with me
in a fruitful way. How was he able to occupy the present
moment so monumentally?

> I believe that all great art holds the power to dissolve things:
> time, distance, difference, injustice, alienation, despair. I
> believe that all great art holds the power to mend things:
> join, comfort, inspire hope in fellowship, reconcile us to our
> selves.
>
> TILDA SWINTON

I visit art museums whenever I can because the experience is
always worth the effort and is occasionally transformative. I
have never regretted a museum visit. But for years I avoided

the work of the early abstract expressionist Agnes Martin. I buzzed past her paintings, never lingering long enough to be affected by them. At first glance, her pale canvases felt, to me, cool and removed. I supposed that the meditative and repetitive quality of her canvases was purposeful, but the faint grids and obsessive detail did not attract my attention or draw me towards them.

Martin's paintings came into prominence in the early 1960s in New York City, but she bristled at the big-boy abstract expressionists around her—Mark Rothko, Jackson Pollack, Robert Motherwell, Barnett Newman and others—and her canvases stand in sharp relief to their bold expressiveness. In several of her writings, Martin stated that she wanted to avoid ego in her work and was committed to conveying positive emotional states of being, including happiness and joy and freedom.

I read that Agnes Martin's work cannot be appreciated in reproduction and that in order to experience her work at all, one needs to be actually present with the canvases. And so, I decided to spend an afternoon with Martin's paintings at a special exhibition of her work at the Guggenheim Museum in Manhattan. I moved slowly down the vast spiral ramps of the Guggenheim's Frank Lloyd Wright Building and allowed enough time for the canvases to speak. And they did. After a while, I was able to feel a palpable presence and power emanating from the paintings and being with them created in me nothing less than a sensation of spaciousness. The canvases did not strive to impress or overpower me with self-expression; rather, they provided an environment for resonance.

The Present Moment and the Digital Space

We live in an era of simulacrum, where songs and paintings are copied and reproduced, almost infinitely; turning art into data. While technology and the internet can reproduce sound, light,

words, and pictures over and over again, it cannot reproduce space and it cannot reproduce time or breath or ephemerality. The theater resists the tyranny of simulacrum. Digital media cannot reproduce the experience of being present.

The theater also utilizes all of the main ways in which humans learn, visually, aurally, and kinesthetically. It is simultaneously real and metaphorical. It is both emotionally removed and deeply empathic, fleeting, and transient. You have to stay alert to the experience. You have to pay attention, to live through the experience and then to transform it with your imagination from metaphor into meaning. You matter because theater does not exist without you. This is not a common experience in the digital environment, experienced in separate rooms. In the theater, you are required to hold your seat by the sheer fact of sitting next to strangers, by the necessity of turning off your phone and screen, by not bothering other people, by listening, by having faith, by holding still, and exercising empathic responsiveness, by opening your heart and mind, by thinking together and imagining together and laughing together. The mere act of going to the theater requires you to express respect to other human beings. The engagement demands physical intentionality and transformation.

I have seen, I have heard, I have touched, I have felt, I have been present.

JACQUES DERRIDA

The experience of performance artist Marina Abramović's work *The Artist is Present* at the Museum of Modern Art (MOMA) in New York City in 2010 provided one of the most powerful examples of audience-as-witness in the context of performance that I have ever encountered. Abramović's stated goal was to remain "in the present" for the approximately 731 hours and 30 minutes that the performance lasted. She invited audience members to both witness and join in this presence. She sat silently at a wooden table across from an empty chair in the atrium of MOMA and waited as people took turns to

sit in the chair and lock eyes with her. Over the course of nearly three months, for eight hours a day, she met the gazes of 1,000 strangers, many of whom, including Marina, were moved to tears. Her act of dedication to this intentional task was nothing short of monumental.

I waited in line for several hours before taking my place across the table from her. Then, I had to ask myself, was Abramović bearing witness to me sitting across from her or was I, sitting across from her, bearing witness to Abramović's vigil? Or, alternatively, was the large group gathered around us bearing witness to our encounter? She looked tired. In my mind and without moving my lips or making a sound, I spoke to her, "You must be exhausted." I said, "You can rest now while I am here. I will hold you up." I imagined that I could feel a slight relaxation in her body. After about ten minutes I thanked her, again silently, and left. The resonance of the encounter with Marina Abramović and her dedication to *The Artist is Present* exists in my memory to this day.

I cherish moments in art, music, or performance where, after a dramatic build or a period of roiling, searching, and struggle, everything stops and I am, as spectator, listener, or viewer, suspended mid-air in what feels like an eternity. At certain crucial moments, the very complexities and paradoxes that make the play so arresting, unexpectedly fall away and suddenly the audience, rather than rushing forward into the next plot point, is stopped, arrested, and suspended together in the present moment. In these precious moments, I feel as though I am falling lightly through space. Vertical time offers a sense of vastness from the inside and it can indeed feel like falling—falling into the arms of emptiness. In those moments I remember that between the past and the future there exists another, often forgotten aspect of time that feels both spacious and unpredictable. Vertical time peels back the layers to reveal the essence of life in the present moment. The surrender that is required in order to experience resonant vertical time can feel a bit destabilizing. Perhaps, when the outcome is uncertain, one needs a special courage to be in the present moment.

Sober and Quiet the Mind

There are two principal parts of each personality: the conscious mind and the unconscious, and these are split and dispersed, in most of us, in countless ways and directions. The function of music, like that of any other healthy occupation, is to help to bring those separate parts back together again. Music does this by providing a moment when, awareness of time and space being lost, the multiplicity of elements which make up an individual become integrated and he is one.

JOHN CAGE

As a young man, John Cage underwent a creative and personal crisis. Not only was he struggling at the time with his attraction to men, leading to difficulties in a culture that at the time did not embrace homosexuality, but he also hated the idea of creativity as self-expression. Due to these personal struggles, Cage felt blocked and uninspired to compose. Caught in the turmoil of his emotions, he was forced to face an essential question: What is the "self" that is being expressed? Eventually he came to terms with his identity as a homosexual and he also addressed his creative crisis about art through the study of Asian philosophical traditions. In particular the Buddhist teachings of Roshi Shunryu Suzuki began to ease his conflicted feelings and inner turmoil. And gradually he found inspiration in non-Western notions about the role and function of artmaking. He wrote, "I could not accept that the purpose of music was communication ... I determined to give up composition unless I could find a better reason for doing it than communication ... I found this answer from Gira Sarabhai, an Indian singer: 'The purpose of music is to sober and quiet the mind, thus making it susceptible to divine influences.'"

I, too, do not trust the assumption that the task of an artist is simply to express oneself. I too am drawn to the idea of creating art that allows the audience's mind to "become more

susceptible to divine influences." Perhaps my own current dissatisfaction with art as pure and unmitigated self-expression is the result of the intense barrage of technological information, communication, and over-sharing that now floods and feeds into our daily lives. Rather than the communication-of-self (self-broadcasting) as the goal of art, I prefer to create the conditions in the theater in which spaciousness, integration, and perhaps even occasionally the ecstasy of the privileged moment may be shaped and embodied.

Throughout history, the theater has been useful in specific ways at particular critical moments. Productions of tragic plays, for example, were invented in ancient Greece to provide a space and time for citizens to absorb the new concept of democracy and to consider the ramifications of democratic law and hegemonic order. In another context, for example during the reign of more recent totalitarian regimes, when freedom of expression is repressed, the theater, via metaphor and allegory, can allow for communication through indirect allusion. Currently, we inhabit a culture in which busyness and distraction have become not only the baseline of modern existence, but also a subject matter of great confusion and concurrently, of great urgency. The theater is in a unique position to offer alternatives to the fast pace and panic of our times. One of the most powerful aspects of the theater is the artists' ability to alter the audience's sensation of time. We can change the experience of time by first paying attention to how time passes.

Horizontal Time

It has come to this: I'm sitting
under a tree
beside a river
on a sunny morning.
It's an insignificant event
and won't go down in history.

It's not battles and pacts
where motives are scrutinized,
or noteworthy tyrannicides.

 WISŁAWA SZYMBORSKA

Several years ago, the performance artist and composer Laurie
Anderson spoke with the directing students at Columbia
University and advised them never to tell their dreams to other
people. "No one *ever* wants to hear the details of your dreams,"
she said, "they are just not interested." Later I shared Laurie's
insight with Leon Ingulsrud, my colleague and Co-Artistic
Director of SITI Company, who then proposed a few other
things that people never want to hear about: "People never
want to hear about how busy you are or how tired you are,"
he said.

And yet busyness and tiredness seem endemic to modern
existence. Motivated by the conversations with Laurie and
with Leon, I decided to simply stop using the words "I'm busy."
Not only did I stop saying "I'm busy," but when anyone insisted
that I must be so busy, I denied it. "No, I am *not* busy." When
I changed how I spoke, the effect was momentous. When I
stopped *saying* "I'm busy," I stopped *feeling* busy. And when I
stopped feeling busy, I stopped feeling tired. Perhaps busyness
is a state of mind that is self-programmed, put onto automatic
drive and then it profoundly affects the moment-to-moment
experience of living. How I think about my life, what I focus
on and how I describe my feeling about time passing, becomes
my experience of time and then, in turn, it becomes my reality.

When busy, when I am trying to get from where I am to
where I want to be, I fall out of vertical time and headlong into
horizontal time. Horizontal time is linear, and it has a past that
is remembered and a future that is imagined. Horizontal time
can make me feel under pressure and it can make me feel slight
and insignificant. Vertical time, in contrast, may contain
horizontal time but it also intersects and disrupts the experience
of linear time. It is in vertical time that the conditions are ripe
to experience the resonance of the present moment.

The danger with busyness is that it can too easily become the baseline of my day-to-day experience, which means that I live in thrall to it. And then I simply forget that I have the agency to make my own choices. Does busyness give meaning to my life? Does it keep me from feeling depressed or keep me from the tyranny of empty spaces? Does busyness make me feel important? Without intense vigilance, my experience of living can slide into default modes. Distractions pile upon other distractions. Moments slip by unmarked. Stress escalates. And beneath all of the noise, I know that distractions weaken the mind, stress can kill, and that the moments that slip by unattended are precious.

The internet has exacerbated our psychological dependence to being online, to a feeling of connection. "FOMO" is a form of social anxiety that expresses a feeling of concern that an opportunity, a novel experience, or some lucrative investment of attention is being missed. FOMO is a fidgety fear and it has increased exponentially with technology. Social networking encourages us to constantly compare our status with others'. Anxiety from a feeling of disconnection results in increased anxiety. The way people feel about the stress in their lives can be an effective predictor of their general health.

Alternative Time Signatures

In light of the fact that the day-to-day speed of our contemporary culture is accelerating at such an alarming rate, the theater, in particular, has the urgent task to provide audiences with alternate time signatures. A theater maker's most consistent obstacle is time. We are all generally under the pressure of deadlines and financial restraints as well as doubts and fears about our own capabilities. The theater may be the ideal medium to address the time-illness that currently plagues our culture by stimulating and cultivating patience, which is also known in psychology as *temporal intelligence*. In order to stimulate temporal intelligence in the theater, to generate

moments that transcend the rush of time, it is the artists themselves who must start by developing a hypersensitivity to issues of time.

One of the basic tools that a theater actor must develop is the ability to occupy the present moment. But performing in front of an audience is highly stressful which makes it very difficult to calm down, relax, and be present. Effective theater training purposefully creates stressful circumstances so that the actor can learn how to relax under that pressure. Sensitivity to time increases when anxiety decreases.

The Dutch actress Saskia Noordhoek-Hegt participated in a theater workshop led by a Buddhist monk. At the start of each session, she said, the participants were required to get onto their hands and knees and scrub the floor of the studio with cold water until told that they were to stop and proceed with the day's work. Quite irritated by the necessity to clean an already spotless floor, Saskia's impatience intensified over time. One day towards the end of the course, the participants were left cleaning the floor for what felt to Saskia like an inordinate amount of time. Her impatience and frustration with what felt like a futile task escalated until, all of a sudden, on her hands and knees in the midst of brushing the floor, Saskia's anxiety fell away and she found herself smack dab in the present moment. She finally understood that this practice was the point of the workshop. She had learned how to cultivate vertical time.

Finding Resonance in the Rush of Time

Good theater training develops strategic patience. In the moment that the ancient flight or fight impulses arise, it is possible, through practice, to apply the brakes, resist rushing, think fast, and slow down, all at the same time. To find resonance in the rush of time requires practice at being rooted in the middle of an action, in the moment, rather than striving

blindly and nervously towards a goal. To consciously shift the mindset from aggressively pushing forwards to an interest in exploring the richness of the moment, a shift in awareness is required. Rather than constantly planning a pathway to what one wants to attain, the present moment can offer an access to fresh sensations and experiences.

Effective actor training should offer tools that help the actor to animate their receptivity to what is happening in the present moment and augment the ability to differentiate one moment, one sensation and one time signature, from the next and the next. Sensitivity requires flexibility and openness to stimuli and this in turn begets precision in stage movement as well as definition and clarity.

In our current techno-arena, the struggle to stay conscious demands that I intentionally change my relationship to time, to duration, and to the shiny objects that grab attention, but mostly have little substance or relevance to what I am trying to do. Rather than flitting from one post, from one shining object to the next, I must learn how to stretch out time and savor moments of being. The first step towards stretching out time and lingering longer is to distinguish between reaction and response. A reaction is instant, and it is driven by deep-rooted beliefs, biases and prejudices of the unconscious mind. Reaction tends to be defensive and automatic. In the face of imminent danger, I am, apt to react rather than respond. But reacting is not always the best way to function in the world. The more reactive I am, the less empowered I am. To respond, on the other hand, I must slow down, take into account the big picture and recognize other choices that are available to me in the very moment that I am about to react. Reaction is sporadic, emotional, knee-jerk and often tense and aggressive. Response takes note of these emotions but also understands that the emotions are transient, and often misleading. Response blends both logic and emotion and generates choice.

It is we who are passing when we say time passes.

HENRI BERGSON

In lingering longer, I do not have to become a Luddite. Current developments in neuroscience suggest that what I rest my mind on is the primary shaper of my brain. What I pay attention to and how I pay attention matters. But our interaction with technology is incrementally changing the very fabric of what it means to be human and consequently altering the way we develop relationships with others. It is also shifting some of the fundamental functions of the theater.

I directed George S. Kaufman and Moss Hart's *Once in a Lifetime* at the American Repertory Theater (ART) in Cambridge, Massachusetts in 1990. An American comedy from the 1930s, the play, about three ne'er-do-wells trying to make it in the movie industry, mixes vaudeville, fast talk, antic misadventures, and the shift from silent film to talkies in Hollywood. There are only two leading female parts in the play: the ingénue, in our production played by Candy Buckley, and the gossip columnist, played by Christine Estabrook. In the entire three-act play there is only one short scene in the second act that features the two women alone together. The two characters run into each other in the reception room of a movie mogul's office and they have a brief interaction. On the day scheduled to stage the scene, I breezed into the rehearsal hall and suggested to Candy and Christine that it would be pretty straightforward and that it would not take long to stage. I was about to plunge into some basic instructions but Christine Estabrook, a great actress with impeccable comedic instincts, stopped me and suggested that we take some time and look into what the scene might really be about. I resisted, looking at my watch, conscious of how little time there was and how much was left to rehearse other scenes that day, and repeated that it would be quite straightforward and that we could stage it quickly. I am so grateful that I listened to Christine because, due to her insight, this scene, which I had thought of as inconsequential, became the crux of the play. The two women ended up together under the receptionist's desk, which framed them like a small proscenium. Two women, vulnerable and human, bonding in the middle of the male-dominated film

industry, in the middle of Los Angeles, crouched where people usually put their feet. At each performance, time seemed to stop at this staged metaphor for male domination, and the audience found themselves suspended in a small pool of spaciousness and time. The scene that I had wanted to stage so quickly and efficiently, proved to be the key to the present moment.

Communality

By providing what is now the increasingly rarefied opportunity to linger longer together in a social milieu, the theater is becoming an increasingly vital art form in an impoverished world. Audiences can not only experience duration and co-presence, but by following meaningful narratives, they can imagine and ruminate together on the quality of the very social fabric that connects them. Live theater provides one of the few places and times where a group can contemplate social and political issues together. Audiences' needs are different now than they were even a decade ago. What we long for, how we make plans, why we go to the theater, and even the quality of space between us has altered. Durational experiences are key to our ability to thrive and live together successfully. It is vital to keep asking how the theater functions in our current social, cultural and political moment. It behooves us to keep our fingers, on the pulse of the ever-changing world.

Meanwhile, even as we ask these questions, our patience is power. Restraint is a tool. In rehearsal, we have the opportunity to practice strategic patience; waiting purposefully for solutions to arise. Rather than allowing time constraints to make everyone tense, we can consciously linger in the middle of a moment rather than racing towards the endpoint. Where patience may at times feel like lack of freedom, or lack of spontaneity or agency, it turns out that, on the contrary, patience is a form of control over the rapidly passing time that otherwise controls us. As the aphorist Mason Cooley wrote, "The time I kill, is killing me."

On tour with SITI Company to Minneapolis several years ago, I searched for and found a Saturday morning yoga class. Arriving at the yoga studio, I noticed a crowd of people waiting to get into the class. Not only had the receptionist not shown up, but also the studio's computer was broken and so the teacher for the scheduled class was obliged to check people in as well as teach the class, which was supposed to have already begun. The line of people trying to get into the weekend class was long and everyone was growing impatient. I stood in the line and when I arrived at the desk where the yoga teacher sat at the broken computer, I said to her, "You are practicing your yoga *right now*, aren't you?" She nodded slowly in agreement.

10

Civility

Tell Your Story

The South African playwright Athol Fugard proposed that there are three conditions required to be a good human being: 1. You need food, water, and shelter. 2. You need parents who love you. 3. And you need to be able to tell the story of where you came from. "Imagine two groups of strangers approaching each other from a great distance," he said. "What do they do when they reach one another? Well, they tell the story of how they got there."

This notion of strangers telling one another their stories is central to the art of the theater. Courage, patience, skill, listening, and openness are required to sustain a handshake from a stranger, not to mention a designated enemy. Poet and activist Maya Angelou wrote, "There is no greater agony than bearing an untold story inside of you." In prehistoric times, humans transformed fire from a dangerous and destructive material into a controllable asset, invaluable to human civilization. Perhaps it would be beneficial to maintain a connection to the original danger of facing off with strangers by learning effective techniques to shape our fears and trepidation into communicative exchange. Because human encounter is the heartbeat of the theater, keeping calm and meeting danger with patience and skill is a requirement for a solid artistic technique.

Many animals fight to defend their own territory, but few enter into sustained warfare. Human beings and ants are the two planetary species that share the capacity for massive, unrelenting warfare. Even in this century, we humans continue to manufacture countless artifacts whose sole purpose is to kill other human beings. Is there an alternative to physical violence? Is it overly optimistic and utopian to propose that another option to war might be to approach one's enemy, shake their hand, and tell stories about where you both come from? Can stories present an alternative to war, to alienation, and to violence?

When restraint and courtesy are added to strength, the latter becomes irresistible.

MAHATMA GANDHI

Much like a frog placed into a slowly heating pot, not noticing that the heat is escalating dangerously, I wonder if we, who live in the current cultural and political moment, are unaware that our civic space is eroding, bit by bit. Are we gradually giving in to uncivil behavior? Are our daily lives bit by bit losing the benefit of big-hearted social exchange and perceptive discourse? The Trump administration has accorded unspoken permission to be rude, to use abusive and dismissive language, to indulge in uncivil attention, all which tend to diminish the quality of social interaction. As our public discourse is becoming a toxic soup, is the social arena deteriorating as well?

Managing Rage

The public arena has largely become a trigger-ready culture of outrage and complaint, and many of us have become complicit in the social media frenzy. We identify with our small angers and resentments, which seem to give us the illusion of control and power over the present moment. Gone unchecked, the situation is dangerous because our own anger and shared outrage also

seem to entertain us and maybe, even momentarily, it makes us feel better. The German philosopher Peter Sloterdijk used the term "rage banks" to describe the way that disparate grievances can be organized into larger reserves of political capital. But rage and frenzy does us no good because, rather than funneling our rage towards positive action and creative expression, our own rage is turned towards others and consequently against us.

The inherent instability and vulnerabilities of the human brain are not only being manipulated in the current political arena but also are the object of Silicon Valley. The very people at Google, Twitter, and Facebook who helped make technology so addictive, are disconnecting themselves and their families from the internet. Meanwhile, a great deal of research and expense is dedicated to ensuring that our devices are as addictive and compelling as possible. The electronic systems that track our personal data and movements in the world are also increasingly used against us. And in this way, bit by bit, our own rage is being turned against us for commercial, and now political, aims.

Ultimately, outrage, screaming, and whining solve nothing. In one of the final interviews that the great Canadian composer-singer Leonard Cohen recorded shortly before he died, the interviewer asked him about his music and also about being a great "ladies' man" and a dedicated Buddhist. Cohen joked that many people imagined that he spent a lot of time bedding fabulous women but in fact most of his time was spent scrubbing cold floors in a Buddhist monastery. The interviewer then asked what all those years of Buddhist practice taught him. Cohen paused and spoke succinctly but effectively, "I learned not to whine."

Intentional Civics

Democracy is not simply a license to indulge individual whims and proclivities. It is also holding oneself accountable to some reasonable degree for the conditions and peace and

chaos that impact the lives of those who inhabit one's beloved extended community.

ABERJANI

In 2018, I spoke about art and politics to students at the New School in New York City. A young undergrad named Elliot Waples raised his hand and suggested that I use the word *civics* rather than politics when considering the intersection between activism and artistic practice. He suggested that, in order to awaken civic responsibility, it is important to think of civics as what happens to the space *between* people rather than what happens *within* specific individuals. He continued in an email exchange: "Civic space," he wrote, "is always in action regardless of distance or will or action. There is no moment where bodies can exist without negative space and therefore there is no moment where civics is not practiced."

After our exchange and hungry to dig deeper, I searched for other definitions and descriptions of the word *civic*. The most satisfactory was, "The duties of citizens to each other as members of a political body and to the government." But even this came nowhere near the acuity of Elliot's conception of civics. As I understood his hypothesis, our attention to civic space and civic action can focus our political interactions. Because, as he suggests, the space outside of an individual is always active, so it follows then that in order to live and act responsibly we need to attend carefully and consciously to the space between bodies.

In graduate school, Elliot plans to study what he calls *Intentional Civics*. I believe that he invented the term and that he will have to forage different academic disciplines in order to assemble a curriculum. According to Waples, the way that space is attended to and activated, how bodies and groups react to one another, is what makes for civil discourse. *Intentional Civics* is where the individual body is aware of the "civic-ness" of space and is working actively to strengthen its bonds, regardless of people's culture or profession. Politics, he says, is contingent upon active civic choices.

Space

In the current pandemic world in which I am writing, I find the notion of *Intentional Civics* particularly useful when examining how to adjust to the new spatial dynamics of our environment. Because every other person on the street or in a grocery store may be contagious, the space between us can be considered dangerous and charged with tension and threat. But in these moments of social and spatial exchange, it is crucial to consciously choose how to respond and how to treat the space in between. We can either react to others with fear and selfishness or we can project and communicate respect, friendliness, and good humor. Due to the current hypersensitivity to health and safety, we are increasingly sensitized to something that has always been true about our responsibility for the entire space and for those within it. Being together in this way requires us to occupy the present moment with one another in a heightened and responsible manner.

As individuals, we are generally territorial and feel in control only in relation to the quality of our spatial environment. Personal space is usually an invisible boundary, a region surrounding a person which they regard as psychologically theirs. Most people value their personal space and feel discomfort, anger or anxiety when that space is encroached. The anthropologist Edward T. Hall, in his book *The Hidden Dimension*, coined the word "proxemics," to describe how space is used in human interactions. He classifies social distance in four categories: 1. Intimate distance (direct contact); 2. Personal distance (1–4 feet); 3. Social distance (4–12 feet); and 4. Public distance (12–25 feet).

Normally our attention to time and space is unconscious. We weave around one another, for the most part avoiding collision, not even aware of the dance that we are enacting. With social distancing, I notice that people are becoming hyper-aware of other people and the distance around and between them. The space between people is charged with a wakeful tension. Roger Cohen, columnist for the *New York*

Times, described the way that people veer away from one another on the streets of New York as the "Coronavirus swerve." Perhaps our sense of proxemics is gradually altering.

If we can work towards an awareness of space and time that is collective rather than individual, we will gradually come to understand that our behavior in the public arena is an investment in the social fabric that connects us. As we switch our attention to the horizontal nature of our social system, and away from hegemonic vertical power structures, we will become stakeholders in the very social system that we occupy. This adjustment to *Intentional Civics* has the potential to build empathy and to inspire a call for social change.

One of the most profound innovations of the ancient Greeks is that serious philosophy is presented as a dialogue rather than a monologue. Plato proposed that the truth exists, not on one side or another, but *in between.* When two people are talking or two groups are engaging, the truth is present but not owned by either side. I am beginning to think of *Intentional Civics* as the art of civic conversation that depends upon mutual respect, compromise, collaborative decision-making, respect for freedom and human dignity, empathy, open mindedness, tolerance, ethical integrity, and responsibility to a larger good. If we want to shepherd and protect democracy into the future, we must understand that democracy is about the discussion, the debate, and the notion that everyone should be heard and that perhaps we have something to learn from the person who has not yet spoken.

Restraint and Civility

Sometimes you have to pick the gun up to put the gun down.

MALCOLM X

In 1981 I directed a play with the graduating acting students at the Max-Reinhardt-Schule, the leading acting academy in West Berlin at the time. One day, the actors asked if I would

be interested in taking part in an exercise that they had been doing regularly over their three years of training. I was curious to try and so I showed up for one of their sessions, ready to participate. We divided into groups of four and the instructions were explained to me. One member in each group is blindfolded. For the first five minutes, the three without blindfolds offer the blindfolded actor a calm, supportive physical journey through the space. Then during the second five-minute sequence the three start to gently push the blindfolded person around. During the third five-minute sequence the three brutally push, shove, kick, and slap the blindfolded person. For the final five minutes, the blindfolded person receives comfort from the three. In the first round I was one of the three in the group without a blindfold on. I was shocked to find that when it came to the third sequence, the beating, I experienced a certain thrill and excitement at abusing the blindfolded person. The permission to be aggressive released an unexpected streak of violence in me and I found myself pushing and shoving with vehemence. Then when we switched, and it was my turn to be blindfolded, I was again surprised at my own physical intensity when, after I was beaten, and while the three actors tried to comfort me, I lashed out violently. I would not let anyone come near me much less touch or comfort me. In both cases, as the perpetrator and as the acted-upon, I was surprised to recognize the violence that that had been awakened in me, that lurked within me, just below the surface. Facing this innate violence showed me the true importance of restraint and civility outside the parameters of the theater exercise.

After the experience with the acting students in Berlin, I felt more in touch with the darkness within me. I do not necessarily recommend the exercise, but by taking part in it I learned that my capacity to hurt others is real and close to the surface. As the Swiss psychiatrist Carl Jung wrote so brilliantly, "No tree can grow to Heaven unless its roots reach down to Hell." Previously, I had thought of myself as a peace-loving person who would never hurt anyone. But in Berlin I realized that

I am actually quite capable of violence and that without restraint, I might too easily follow blind impulses in service of short-term gain. Without self-control I am selfish and irresponsible, I lie and become oblivious to others. Without restraint perhaps we all incline towards immaturity and irresponsibility. This goes to the heart of issues around civic responsibility, personal freedom, rationality, and emotion. I believe that it is possible to combine personal freedom with civic discipline. When impulses are regulated, organized, and unified by civility, the world can take on deeper meanings and consequent actions. Ideally, as we grow up, we learn how to use the prefrontal cortex of our brain to exercise restraint. But it is tough to live in a world that manipulates and assaults us daily, hourly, in every minute, one that encourages us to push the button, to buy the thing that will make us feel better and that will give us what is ultimately short-term gratification. Restraint is a discipline that can help us to find meaning and to consider and collaborate with others.

If civilization is restraint, then it is the artist's job to transform the energy and the danger of meeting, of encounter, into communicative expression. The Spanish word *encuentro* is generally translated as *encounter* but its root, *cuento*, means *story*. In the moments of reactionary violence, impatience, and despair, art steps in as a tool, a technique that requires skill, patience, a personal point of view, and a story to tell. The creative act demonstrates the human capacity to temper violent, reactionary impulses and to transform them into communicative display, declaring through various means, "This is who I am. This is where I come from. Do you relate to any of this?" Through art, perhaps fear can be transformed, violent instincts tamed, and the impulse to protect oneself just might be converted into a veritable handshake.

Collaboration vs. Teamwork

*The lightening spark of thought generated in the solitary
mind awakens its likeness in another mind.*

THOMAS CARLYLE

The theater is a collaborative art form. Everything that we do
requires cooperation and shared decision-making, beginning
with the playwright handing us her play and asking us to read
it. In a rehearsal, everyone directs a different part of the
production. The actors direct their own roles in relation to
other actors and to the audience. The lighting and scenic
designers direct the attention to space. The sound designer
directs the auditory experience. The dramaturg directs the
attention of everyone involved to salient issues that are
overlooked. The director maintains space for the collaborators
and orchestrates how all of the elements intertwine and speak
with one another.

Teamwork and collaboration are two terms frequently used
in the theater and are often considered to mean the same thing.
In fact, although both words are similar in nature and refer to
achieving a common objective, the process of each is quite
dissimilar. In teamwork, a group performs their individual
roles in order to contribute to the achievement of a common
goal. In collaboration, all individuals are partners that share
work, ideas, and insights in order to achieve a shared objective.
Teamwork requires a group to be efficient while working
under one leader. Each individual brings her own expertise
into harmony under the auspices of a clearly articulated goal.
Collaboration requires deep respect for others, for their
opinions, and their proposals. Teamwork, unlike collaboration,
requires the tight control of single leader. In a collaborative
environment, flexibility is central to the process. The group
must not only function effectively as a team, but it is also
essential that they are able to think laterally together. The best
collaborators are not only creative, they are flexible. They
know when to allow others to take the lead. The end product

of both collaboration and teamwork are similar but the means to that end are quite different.

Enter any rehearsal space and you will immediately sense whether the environment is one in which choices are being made collectively or if a single person is making all of the decisions. In the teamwork model, the actors and designers wait for the director to give instructions. For me, the most exciting working environment is one in which individuals in a group, much like jazz musicians, make myriad decisions together, moment by moment. They improvise together in the heat of rehearsal in order to discover the most effective and expressive solutions. Everyone shares the search for vital, rich moments of theater. The group collectively creates on their feet while posing questions about order, chaos, structure, and chance.

But collaboration is not only about agreement. The best group decision-making encourages diverse points of view, creative disagreement, and abundant civic restraint. Successful collaboration in the theater consists of both horizontal and vertical systems. The vertical system embodies the intention, the vision, the shared goal, and a sharp awareness of what the group is trying to accomplish together. The horizontal system is the manner of communication amongst the group. It is on the horizontal plane that creative disagreement is both necessary and desired. A balanced combination of the horizontal and the vertical planes requires effective civil communication.

Part of my job as the director is to make sure that everyone is on the same page from the beginning of rehearsals. To function productively, to create the right conditions for collective decision-making, everyone must speak the same language and agree upon a goal. This represents the vertical plane. In order to ensure effective action on the horizontal plane, I must consistently recognize each individual's input so that they are seen and heard. I must encourage diverse points of view, be open enough to try out other perspectives and give space for every person to convey their particular point of view. And all of this must happen in a way that is not chaotic and

that successfully functions within the allotted time and given financial limitations. I set the parameters for the rehearsal process, propose a strategy, initiate the action, and then watch and listen, paying close attention to what the collaborators bring into being. To collaborate, to improvise and make decisions together, requires acute listening, respect, and the capacity to be ceaselessly inventive amidst group negotiation. Civility is an absolute necessity in rehearsal. I constantly scan the myriad decisions that the individuals in the collective are making, and then I edit, making choices that will help the audience to see and hear clearly. I bring my own taste and point of view into the process. Together we attempt to craft a progression of suspenseful events that will communicate successfully to an audience.

To create in concert with others requires that each person listen closely to one another and make micro-decisions constantly. An actor who waits for me to tell her what to do is not useful in this initial phase of rehearsal. To make decisions together, everyone must be able to read and to write effectively; to read the room, read each other's faces, read body language and read the myriad changes taking place in every moment. To write, an actor must make effective and legible choices and actions instantaneously, based upon what is read. To read and write fluently requires an understanding of the grammar of the stage and the syntax of space and movement. The group looks at the situation together and makes small tests. Even in the most enraptured moments of discovery, there is careful deliberation.

The audience shows up as the final collaborator. Actors instinctively know the extent to which the civility of an audience plays a role in the success or failure of a performance. From the outside, an audience may appear to be a passive participant, but this could not be further from the truth. How much audience members decide to "show up" on any evening is crucial to the success of the joint enterprise. A receptive and responsive audience can improve the performance of those on the stage and the actors use the information gleaned from audiences to adjust their performance, both in the moment and

for the future. An audience transmits energy and participates in a performance by influencing the timing and the rhythm. At certain moments, the collaboration of silence between audience and actors is essential. In directing a production, I try to provide enough space for the audience to join into the collective decision-making. I look for ways for them to become part of the overall event, including the development of meaning and the timing of each performance.

Within the culture of SITI Company, our shared assumptions about collaboration and making decisions together form the basis of our work together. But when I direct opera, these assumptions about collaboration are not generally in place. The rehearsal process in opera does demand teamwork but generally not so much collaboration or joint decision-making. The financial demands, the strict union rules, and the presence of a usually substantial chorus in opera require the director to arrive at the first rehearsal with the staging fully worked out. And yet, despite the short amount of rehearsal time and the expectation by everyone that the director simply tells everyone what to do, it is possible to create an environment where the principal singers, the chorus, and everyone involved feels that their ideas and impulses matter and that their input can make the work much better than what I had prepared in advance. Both qualitatively and quantitatively, making decisions together is the core value to which I always return.

> A true leader has the confidence to stand alone, the courage to make tough decisions, and the compassion to listen to the needs of others. He does not set out to be a leader but becomes one by the equality of his actions and the integrity of his intent.
>
> DOUGLAS MACARTHUR

Ancient Greek theater emerged from ritual and sacrificial slaughter. According to some theories, the lead character in a fictional story, embodied by a living actor within the narrative of a play, replaced the animal and the sacrifice. The martyrdom

of the character, and thereby the actor, became increasingly symbolized. The audience witnessed the actor enacting the journey of martyrdom, both through the story being told and in the actual trial of being onstage, in public, and exposed. The actor acts and undergoes physical and emotional exposure for the benefit of the audience.

We attend the theater in order to experience the real event of actors undergoing intense experiences in our direct proximity. Audiences naturally crave the force of human heat at the center of a theater production. We revel in being a witness to the phenomenon of the actual cost of the performance upon the individuals on the stage. What we probably remember the most about any performance is how we resonated and connected with an actor. The actor is our guide and our orientation to the world of the play and to the trajectory and nuances of the fiction. An actor embodying a leading role requires sufficient amounts of civility, courage, and audacity to bring the audience into the present moment together.

In a Polish production of *King Lear* at the Venice Biennale directed by Jan Klata, Lear was missing. Literally. At first the character of Lear was represented by an empty chair and a recorded voice and later by various visual projections. What the audience did not know, and what I learned later, is that the actor who had originated the role had died a few months earlier. Rather than finding another actor to take over the part, Klata decided to deal with the actor's physical absence within the context of the production. But this choice failed. Little by little, the actor's looming absence sucked the life out of the play itself. As an audience member, I felt a gaping hole at the center of the production. The audience was offered no vitality or no muscle to push up against or to rally around. In the end, as Gertrude Stein said about Oakland, California, there was *no there there*.

Lead Actor

Can we equate the lead actor in a play to the role of a quarterback in football? In American football, the quarterback is the most glorified and scrutinized position in team sports and is usually considered to be the leader of the offensive team, responsible for telling his team which play will be run. He is the civic lynchpin to each and every game. He touches the ball on almost every offensive play and his successes and failures can have a significant impact on the fortunes of his team. What I find most relevant to the theater is how a quarterback can act as a levitating force or an anchor for the rest of the team. Sports philosopher Joe Bussell wrote, "Every team needs and wants a quarterback who can support the team through tough stretches or piles of injuries and ultimately get the team to the Super Bowl ... There are some quarterbacks that are elevated by the talent around them and there are others who are so good that they elevate the entire team with their exceptional skills and leadership."

The leading actor in a play functions in a similar way to a quarterback. She must be hypersensitive to the atmospheric vicissitudes of the stage and at the same time stand as a civic model for the others, orienting both the ensemble and the audience. The actor acts as a levitating and resonating force for everyone present and personally takes the heat from the highest hurdles of the play.

In 1987, the Japanese director Tadashi Suzuki created an English-language version of *The Tale of Lear*, an adaption of Shakespeare's *King Lear*. In collaboration with Milwaukee Repertory, Stage West, Berkeley Repertory, and the Arena stage, Suzuki cast twelve male American ensemble actors from those theaters to rehearse and subsequently tour in Japan and the United States. *The Tale of Lear* was my first experience of Suzuki's work and it proved personally galvanizing and significant in my own trajectory. Deeply affected by the production, the integrity and the experience, this production exists in the top ten theater experiences of my life.

Suzuki is known for his notion that "animal energy" is the basic vocabulary of the stage. He believes that in an increasingly

digital and technological global society we must value the products that are "created by human beings, over time, using their innate animal energy while being mindful of each other's differences." He feels that the job of the theater artist is to honor and magnify what is human as well as the civic relationships that we share and to turn up the volume on human heat in the theater. The theater communicates energy as well as words.

In the role of Lear, Suzuki chose the magnificent American actor Tom Hewitt. Rehearsals took place at Suzuki's theater compound in Toga Village in the mountainous region in north central Japan known as "the Japanese Alps." Tom remembers the first part of the rehearsal process fondly; hanging out with his fellow actors outside of rehearsals, drinking together, talking easily about the play, making comments, and, as he described it, "being distracted, exhausted, and terrified in general." But one day in the midst of rehearsal, as the first public performance approached, Suzuki publicly and severely rebuked Tom for his behavior outside of rehearsal. Suzuki was adamant that as the lead actor in the play Tom should take responsibility for his actions in social situations outside of the work environment. He wanted Tom to act as the leader both inside and outside of rehearsal, off and on the stage. He wanted him to take responsibility for the welfare of the other actors as well as of himself. When I asked Tom via email about his memories of the incident, he wrote, "My sense of the event was, although I was the focus of Mr. Suzuki's wrath, really a wake-up call for the whole company. It worked. We were a tighter ship after that day."

And yet, in the path towards civility and resonance, perhaps each and every actor should approach the stage as the leader, as if playing the lead role. In rehearsal Suzuki expects an actor playing a minor role in a play to be able to step onto the stage at any moment and perform the entire play alone. The actor in this situation is required to take full responsibility for the audience's experience of the play. And in this sense, actors and ensemble are modeling a version of how people might co-exist and flourish with one another in an effective civil and pluralist social system.

Language

> I find that one of the best, but most difficult, ways for me to learn is to drop my own defensiveness, at least temporarily, and to try to understand the way in which his experience seems and feels to the other person.
>
> CARL ROGERS

Each word that we choose resonates with personal meaning. The language that we speak and how we use it shapes our behavior and our worldview. Without vigilance, we tend to default repeatedly to the same terms, phrases, and expressions in the language that we are most accustomed to speaking. Because of that, it is hard to escape experiencing the same feelings, memories, and emotions over and over again. Words have a biochemical effect and the words that we attach to our experiences become our experiences. I believe that exploring languages, exchanging words and syntax or sentence structure, can also alter how we think, move, and interact with the world. To change a language is to change a pattern. Language plurality leads to a more open and accepting approach towards the world. And each different spoken language is a conduit to traditions, cultures, and the possibility of alternate perceptions about how we relate to one another.

My colleague Leon Ingulsrud, a strapping six-foot-two redhead from Minnesota, grew up in a missionary family and spent many years living in Japan. He speaks fluent Japanese. When I am in Japan with him, I watch the incredulity with which the Japanese people, who do not know him, stare at him when he speaks with them. It seems beyond their comprehension that someone who looks as he does would sound so authentic. I also watch how Leon's body language and demeanor alter radically when he speaks Japanese. But I have also noticed there are still traces of Japanese behavior in his life outside of Japan and I like to believe that this is a conscious choice on his part; that he enjoys switching codes. The civil codes in Japanese

society are more formal and conservative than in the occidental world, requiring added respect, civility, and humility.

Language has the power to shape the worldview and identity of its users. A person who only uses one language and is fully saturated in its particular values, ideals, and customs, tends to adapt a mainstream cultural identity. With multiple languages, a person is more likely to embrace multiplicity and ambiguities. Someone who receives a solid education tends to develop a deeper curiosity about other cultures, which, in turn, motivates language learning.

Psychological studies show that bilingual people operate differently than single-language speakers and the differences offer specific mental benefits. Speaking two or more languages can be a great asset to the cognitive process, improving the functionality of the brain by challenging it regularly to recognize and negotiate meaning and to communicate within different language systems. As a multiple language user, one's focus is drawn not only to the mechanics of verbal communication—grammar, conjugations, and sentence structure—but also to the specific nuances of each culture. This increases an overall awareness of language, its construction, and how it can be manipulated and contextualized.

Learning multiple "tongues" advances the ability to switch between different structures, different mindsets and cultures. Distinguishing meaning from discreet sounds develops a better ear for listening, a skill that boosts one's ability to negotiate meaning in other problem-solving tasks as well. Language skills allow one to become a more effective communicator and a sharper writer and editor. To communicate with others requires civility in order to have an exchange. The necessity to improvise while speaking a new language leads to flexibility and attentiveness.

I am writing in English here, my "mother tongue," a language that is deeply embedded in my bones, my sinews, my dreams, and my past. English feels natural to me, a language that I can swim in with a certain fluency and ease. But, in fact, each of us speaks in many languages throughout each and every day. Our

bodies, our gestures and our facial expressions speak constantly to others. Our use of spatial language can either be eloquent and communicative or fuzzy and confused. Space, time, and movement have a distinct grammar and syntax. How close or far do we position ourselves from others is a form of speaking to them. Where do we place pauses? How quickly do we move, speak or respond? How loud or how quiet are we? The grammar of space and time is something that we learn to negotiate throughout our lives.

My friends insist that I have a facility with spoken languages. I resent this assumption because, although I enjoy the study and the effort to learn a new language, I do not have a natural aptitude for languages. I work very hard at each one. I choose each new language because I am interested and, to varying degrees, passionate about it and because the challenges are always palpable and real. And in the end, once I have reached a certain aptitude with the new language, I begin to feel the layers within me thicken, my connection to a new culture deepens, and another worldview comes into perspective. While it is true that there are alternative conduits to diverse cultures, including art, food, and even sports, language has been my pathway to different ways of thinking and interacting with the world.

As well as mental effort and focus, the process of learning new languages requires sensitivity, persuasiveness, civility, vivacity, and perseverance. It also asks for a comfort with ambiguity, miscommunication, improvisation, and guessing. In other words, it requires me to be the best person that I can possibly be. And then, after all of the struggle, the embarrassment, and the fumbling, something does happen. I begin to think and dream in the new language, and I am able to swim in the complexities and distinctiveness of a different culture. Something shifts.

Afterword

We work in the dark—we do what we can—we give what
we have. Our doubt is our own passion, and our passion is
our task. The rest is the madness of art.

HENRY JAMES

During a public interview, the novelist Margaret Atwood read
a passage from her book *The Handmaid's Tale*. Afterwards,
the interviewer, moved and a bit in awe, asked her, "How did
it feel to write that?" Margaret Atwood responded rather
sternly, "I have no idea." When pressed further she said, "When
you are skiing down a steep slope, you do not think about
what it feels like to ski down a steep slope. If you did that, an
accident might occur. It is dangerous to think about what you
are feeling. You are skiing."

At certain pivotal moments in the creative process, we are
required to suspend the usual ego boundaries and give over to
something other than ourselves. In deferring our own likes,
dislikes, and even our customary judgments, we may find
ourselves breathing and moving differently and making
unexpected choices. Only by creating this inner spaciousness
can something extraordinary and resonant come into existence.
What matters in the artistic process is the depth and quality of
the encounter.

A skier must give over to and become one with the terrain.
The act of composing a symphony or making a painting,
writing a book or rehearsing a play requires dedication, a
devotion to something or someone outside of ourselves, a
commitment to the moment and a deep listening to others, to
the materials at hand, to the feeling of space or to the elasticity
of time, or to space and time together. The process is, at best,

full of discovery, invention, and imagination. In a rehearsal, I am required to transcend the boundaries of my own ego in order to meld forces with those who have gathered together and to connect with the themes of the play in the shared space and time that we inhabit. "Only connect," as E. M. Forster famously wrote in his novel *Howards End*. He went on, "Only connect the prose and the passion, and both will be exalted, and human love will be seen at its height. Live in fragments no longer."

If we subscribe to the notion that our lives are inevitably entangled in the lives of others, that we have an effect upon the world that we inhabit by our actions, our words, and even our postures, then we must become responsible to our actions, words, and posture. Cultivation of oneself and one's own abilities is certainly an asset, but in these difficult and challenging times, progress is best achieved through action in concert with others. What matters now is the courage of the encounter and one's dedication, with all of its inherent vulnerabilities and misunderstandings. What matters is to unlearn and then to learn again together; to meet; to commit to one another and to the enterprise at hand. We must engage in these collective actions now so that there may be a future for those who come after us.